# Painting Flowers

## with Joyce Pike

# Painting Flowers
### with Joyce Pike

NORTH LIGHT BOOKS

Cincinnati, Ohio

## About the Author

Joyce Pike began formal art studies with Sergi Bongart at the age of twenty-three, and later continued with Viona Ann Kendall and Hal Reed. She taught art for seventeen years at the Los Angeles Valley College, and now teaches for Scottsdale Artist School, Artist Workshop Tour Agency and others.

For the past several years, Pike has demonstrated and lectured on the impressionistic approach to visual art throughout the United States and Europe and has appeared in more than fifty television programs on art. She is listed in *Who's Who in American Art*, *World's Who's Who of Women*, is a member of Women Artists of the American West, The Salmagundi Club of New York and The American Artist Professional League of New York and won the Notable American Award in 1980.

She is the author of both *Painting Floral Still Lifes* and *Oil Painting: A Direct Approach* (North Light Books), as well as forty-eight one-hour instructional videotapes on painting floral still lifes, landscapes, seascapes, marine life and portraits. She resides in California with her husband, Bob.

*Painting Flowers with Joyce Pike*

Copyright © 1992 by Joyce Pike. Printed and bound in Hong Kong. All rights reserved. No part of this book may be reproduced in any form or by any electronic or mechanical means including information storage and retrieval systems without permission in writing from the publisher, except by a reviewer, who may quote brief passages in a review. Published by North Light Books, an imprint of F&W Publications, Inc., 1507 Dana Avenue, Cincinnati, Ohio 45207. First edition.

96  95  94  93          5  4  3  2

Library of Congress Cataloging in Publication Data

Pike, Joyce
    Painting flowers with Joyce Pike. — 1st ed.
        p.   cm.
    Includes index.
    ISBN 0-89134-419-5
      1. Flowers in art. 2. Painting—Technique. I. Title.
ND1400.P55    1992
   751.45'434—dc20              91-31169
                                  CIP

Edited by Greg Albert and Rachel Wolf
Designed by Clare Finney

### *Dedication*

If you live long enough and are lucky, your life will be enriched by a few great people. Not all will be famous, yet to you, they will mean so much. I have been truly blessed to know several such persons, all of whom have had a special effect on my life. Among these are two great ladies, both are dear to me as friends. But what guarantees them an extra special place in my heart is that they got me started in writing my books. Without their help and encouragement, I might never have overcome my fear of embarking on such an endeavor. With all my heart, I say thanks to you both. This book is dedicated to Dr. Esther Davis and Dorothy Judd.

### *Acknowledgments*

To Greg Albert:
I appreciate all you have done to help me. After working together with you on two books, I can't say enough for your direction and advice.

To Rachel Wolf:
Every great project depends on the work of at least one unsung hero. This book is testimony to your endless patience and attention to detail. You and Greg make a super great team. Thanks a million.

Thanks also to Anita McKee for doing my typing and for general help.

# Contents

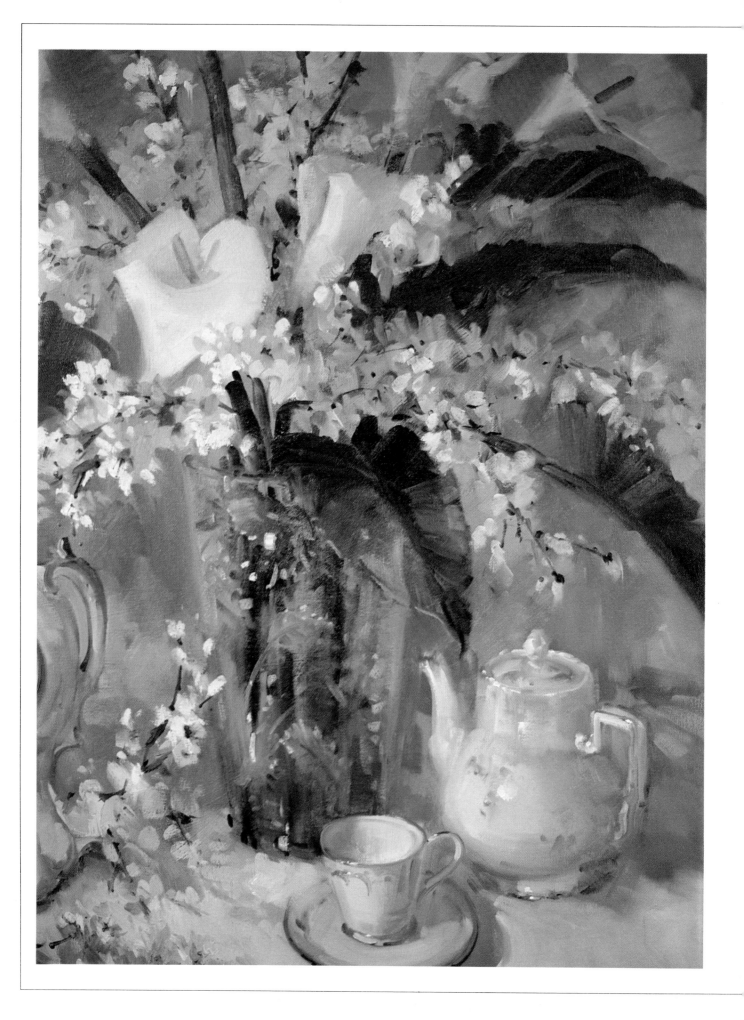

# *Introduction*

Every writer wants his or her book to live forever, giving knowledge to everyone who opens its cover. That is my wish, but I know it won't happen if the book isn't something you can constantly refer to. As I write, I try to keep this in mind. I would like it to continue to be a reference through each and every day you find a need to seek an answer or refresh your memory on a point. There are many books out there that cover the ABCs of painting over and over again. This is necessary for a beginner, but I have tried to speak to the already accomplished artist without neglecting the excited beginner. I have covered my entire painting process in this book, from selecting and arranging the setup to how I finish a gallery painting.

I have been teaching for over thirty years and I have never had a student that was not able to produce or learn to paint. There are many degrees of perfection, but truly anyone with a desire can learn to paint. As you acquire more understanding of how to create a beautiful painting from what I am giving you in this book, I know you will find for yourself not only the desire to paint but the reality of fulfilling your dreams.

**SECTION ONE**

# *Getting Ready to Paint*

It's not the tools you use, but how you use them that is important. Don't run out and buy every brush or tube of paint that comes onto the market. Be selective. A good painter can create a masterpiece with just the three primary colors plus white. You'll need good brushes, but certainly not a hundred of them. I prefer to use no more than ten brushes—not old, worn-out or stiff brushes, but ten good quality, usable brushes. In fact, as I always say, "A painter is only as good as his or her brushes." Tools are important, but they may not make you a better painter. Hard work, perseverance and study will do you more good than all the shiny new paint supplies you can buy.

# Materials

*"Good tools will make painting less of a struggle."*

## BRUSHES

I can't say enough about the importance of good brushes. To me, they are an extension of my arm. Although I may use the same brushstrokes, they won't work the same unless I have the proper tool for what I want to express. Often a student will attend a workshop or class with old, worn-out equipment. Most of it can be utilized, except for the brushes. When they dry out, I don't know of anything to bring them back. Just discard them and invest in a few new ones. Even four or five new brushes will do if you can't get a full set at one time. I use a combination of filberts, bristle brights, and Royal Sable brights for almost everything I paint. I keep a selection of pointed riggers for finish or line work. Since there are different kinds of brushes in my paint supplies, I feel I should explain a little bit about the brushes I use.

*Brights.* A bright is a short, flat, bristle brush with a long handle. It is one of my favorite painting tools. I do a great deal of scrubbing when I begin to paint, and this brush gives me control when I want to cover a large surface quickly. By "scrubbing" I mean applying the paint in a circular or random pattern with a light rotating motion, rather than brushing on the paint in smooth, parallel strokes. I also use brights when I make a straight line, for instance, in windows, doors, sides of a building, fence posts, trees and so on. Because I can control the paint easily with a bright, I like to use it when I need to apply the paint carefully and delicately, such as when painting distant mountains or clouds. I use nos. 2, 6, 8, 10 and 12.

*Filberts.* A filbert is a long, flat brush with an oval point. I use this brush to paint foliage, ground cover, flowers, or areas with irregular shapes, such as tree trunks, branches and rocks. In general, I use a filbert for anything that doesn't require a straight line. The brush holds more paint because of its extra bristle length and can be used when a direct, loaded brushstroke is needed. I use nos. 4, 6, 8, 10 and 12.

*Flats.* A flat is a brush with a long, square bristle

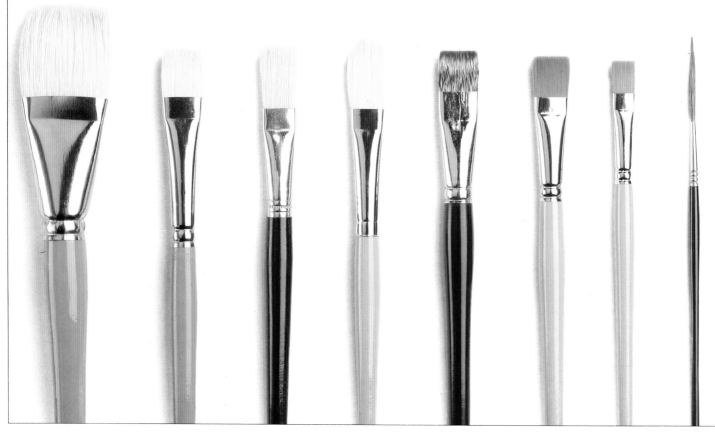

tip. It is sometimes called an "egbert." Of the brushes I use now, flats are my least favorite. I do use a few, mainly when I need to apply a generous amount of paint with a squarish stroke. I use nos. 6, 8 and 10.

*Rigger.* A rigger is an unusually shaped brush with a very long, pointed tip, sometimes made of sable. I use riggers for almost everything from highlighting an eye in a portrait to painting the delicate branches of a tree in a landscape. I even use them to sign my paintings. I use nos. 1, 2, 4 and 5.

*Royal Sable.* Royal Sable brushes are made by Langnickel from sable bristles, but they are firmer and more resilient, or springier. This has always been one of my most favorite brushes, but they are now difficult to obtain. I have been told that Langnickel may discontinue manufacturing them because they can't get the material. When I can find them, I prefer nos. 6, 8, 10, 12, 18 and 24 for detail work and nos. 28, 32 and 44 for large background areas. I have found some good synthetic substitutes for Royal Sables. I recommend experimenting with different brands. The brush you choose should be smooth and springy.

## PAINTING KNIVES

Knives, like brushes, are a personal matter, and each has a separate use. A knife can do things no other painting tool can do, such as applying a thick layer of paint over a thin one where a heavy buildup is needed, or making a clean, direct stroke. It is also a very useful tool for adding a sharp edge to a door or window, or creating a thin branch. A knife won't do the same work as a brush and vice versa. Each has a distinct purpose. Though many painters enjoy using the knife to do flowers or final highlights on flower petals, I don't usually go that route. I use the knife mainly in outdoor landscape work and use little knife, if any, on my floral paintings. The knife is often used for texture, but be careful—this can be terribly overdone. Each knife stroke must be well directed, and practice is necessary to learn the technique's limits.

▶ This is a detail of the knife study on page 33. Knife painting can be a dramatic alternative to traditional brush painting. But be careful not to get so excited by the great textures you can produce that you overdo it.

◀ Here are the brushes I use. I buy new brushes often because good tools are important to the success of your painting. From left to right: large flat, bright, flat, filbert; my Royal Sable brush, two synthetics which can substitute for the Royal Sable, and a rigger.

## PAINTING SURFACES

I prefer preparing my own canvases. I use a slightly rough surface with good sizing. Though this subject has been covered in my two previous books, I will briefly recap the procedure here to make sure you get the information. First I buy a large roll of heavy, 100 percent cotton canvas. Then I staple the canvas to the stretcher bars as tightly as possible. I try to make it tight the first time—a floppy canvas will need to be restretched. Next I use two coats of gesso, allowing the first to dry several hours before applying the second. I usually let a canvas sit several days before I start to paint on it. This may not be necessary, but I feel better about doing it this way. There are, of course, many good ways to size a canvas. I have just given you my favorite. If you would like to know more, read page 12 in my book, *Oil Painting: A Direct Approach.*

## EASELS

You will develop personal favorites among your tools just as I have. One of my favorites is a large studio easel made of lightweight aluminum that I had designed for me several years ago. It will hold a very large painting, say 45″ × 70″, and hold it steady because it is supported by two aluminum poles, not just a center pole. It is also light enough to be carried easily and folds up flat so it can be taken outside in the yard or in my van to do a very large painting outdoors. (If you want an easel like this one, a local metal shop would probably be able to make one for you from this diagram.) I also use a French easel with room to tote supplies when out on location. Recently I purchased a half-size French easel that fits under my airplane seat or in the overhead compartment. When I fly, I carry my easel empty and use an old makeup case to take all my supplies, except for turpen-

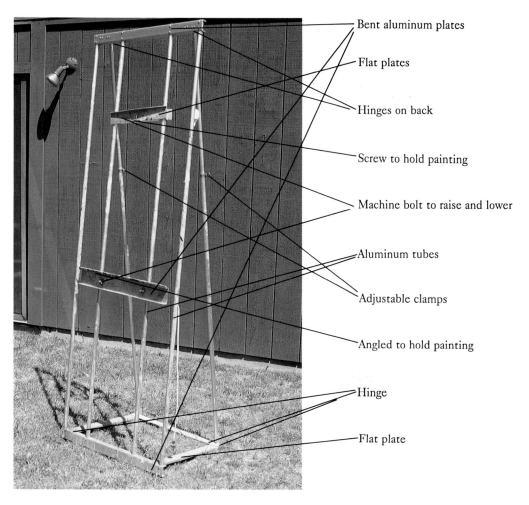

▶ I had this easel made for me, and it is the most convenient I have ever used. I use it indoors and out. It is very lightweight and folds flat. It is 7′ tall, 28″ wide, 22″ deep, and is made of 1″ aluminum tubes and 3″ flat plates. I've included the general specs for it, in case you want to have one made yourself.

Bent aluminum plates

Flat plates

Hinges on back

Screw to hold painting

Machine bolt to raise and lower

Aluminum tubes

Adjustable clamps

Angled to hold painting

Hinge

Flat plate

tine, which I always purchase after arriving. Solvents are not allowed on an airplane.

I like to use a lightweight aluminum easel for displaying paintings or just to have around when larger easels are too big or cumbersome to use. In fact, I find a lightweight aluminum easel has 101 uses. I often use this easel when I have to walk a long distance to get to my outdoor painting site. It is easy to strap on my back and easier to carry than the French sketch box when filled. I use two large easels in my studio, one to paint on and the second to display other paintings I am working on. While I work on one painting, I study the other. This enables me to catch little things I don't see at first. I also do a lot of photography for my books and so forth. The large oak easel can easily be adjusted to perfectly support the painting I am photographing.

## MY STUDIO/WORKSHOP

My studio/workshop answers my every need. It was designed just for me and isn't large, but is entirely adequate. I have several bins to store canvases and frames and many shelves to hold all the goodies I use constantly for setups. The floor in the storage area is carpeted to make it easy to move the frames and canvases without damage. It is very convenient as all the bins are sized according to my requirements. One of my treasures is an old Victorian display easel that I use to hold finished paintings. I also use it to display my work when someone is shopping for a painting.

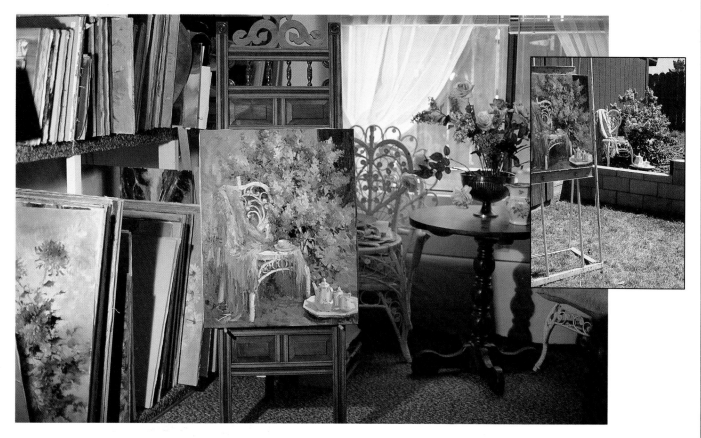

▲ This is a picture of my studio, including the fancy "show" easel I use to display paintings for prospective buyers, and the window that appears in a number of paintings in this book.

▲ I take my aluminum easel outdoors all the time. I like it better than the traditional French easel. Here you can see a setup in my yard.

# Mixing Colors

*"Use color to make a painting sing. Use grays to play the accompaniment."*

What follows is a general description of how I use the colors on my palette. But before we get into mixing colors, you must understand the importance of using clean brush cleaner and medium. You can keep your brushes clean by using a different brush for each family of colors, such as one brush for reds, one for greens, one for yellows, and so on. Clean your palette often, and don't save muddy colors for future use. Experimenting is always good, but don't use more than three colors in any mixture. Don't overblend or overwork. Try to place the paint in one good, clean brushstroke and then leave it alone.

## MIXING EARTH COLORS

I do not use standard tube earth colors. I prefer mixing my own. Earth colors can cause mud in a painting, and for a floral painter, this can be tragic. Good clean color is of utmost importance. I can match the most common earth colors on my palette; however, my mixtures are adjustable because they derive from at least two and sometimes three different colors.

The first color on the chart at right is *burnt sienna*, a red gray. My mixture is cadmium orange, Grumbacher Red and viridian. These three make a vibrant burnt sienna that can be adjusted warmer or cooler.

The second earth color on the chart is *raw umber*. I do occasionally use raw umber when I want a soft gray over my entire canvas or when I am painting a mono-

▲ This detail of *Yellow Roses with Dark Background* on page 101 shows how fresh and colorful my mixed "earth colors" are. They are used in the shadows and background.

# Mixing Earth Colors

### Burnt Sienna

| Tube Color | Cadmium Orange |
| White | Grumbacher Red |
| | Viridian |
| | White |

### Raw Umber

| Tube Color | Sap Green |
| White | Cadmium Red Light |
| | Ultramarine Blue |
| | White |

### Black

| Tube Color | Thalo Blue |
| White | Alizarin Crimson |
| | Sap Green |
| | White |

### Yellow Ochre

| Tube Color | Indian Yellow |
| White | Grumbacher Cobalt Violet |

### Burnt Umber

| Tube Color | Grumbacher Red |
| White | Sap Green |
| | White |

chromatic painting. Sap green, cadmium red light and ultramarine blue were used to get exactly the same earthy color, only more alive.

*Black* is on my palette, but I find that when I mix my own I can adjust it to a warmer black or a cooler black. For this mixture I use thalo blue, alizarin crimson and sap green. This gives a very vibrant black.

*Yellow ochre* is one of the most-used earth tones. For this I use Indian yellow and Grumbacher Cobalt Violet plus white. The clean transparency of the Indian yellow

and the beautiful opaque quality of the Grumbacher Cobalt Violet make an exciting yellow-ochre-toned gray.

*Burnt umber* is the last earth-tone gray I will show you. For this I use the simple combination of Grumbacher Red and sap green. The two will give me an exact match to burnt umber.

Anytime you try to mix these different grays, be sure to add a little white to let you see if they match. Floral painters should know their palettes well and also know and trust their formulas for mixing different colors.

# *Mixing Greens*

Viridian Green

Thalo Yellow-Green

Thalo Yellow-Green
Cadmium Red Light

Viridian Green
Cadmium Red Light

Sap Green
Cadmium Red Light

Sap Green
Cadmium Red Light
(More red)

Sap Green
Cadmium Red Light
(More red)

Sap Green
Cadmium Red Light
(More red)

# *Mixing Yellows*

Indian Yellow

Indian Yellow
Grumbacher Red

Indian Yellow
Ultramarine Blue

Cadmium Yellow
Cerulean Blue

## MIXING GREENS

To me, greens are the neutral backdrops that set off the beautiful colors in the flowers. They are of paramount importance, so the mixtures for these greens must be well chosen. If a green becomes too bright, for example, it can detract from the importance of the flower. However, it is still necessary to know how to make a strong leafy green when you need it. I do occasionally use viridian green or thalo yellow-green for highlights straight from the tube, but I almost always slightly gray all green mixtures.

The first green on the chart at left is viridian green. I added a touch of white to the lower area of the spot of color. This green is good for highlights or to mix with most reds for a soft grayed green.

My second green is thalo yellow-green. Both of these colors were used straight from the tube to show you how beautifully they will work for highlight areas or where strong green is needed.

The third mixture is thalo yellow-green with a tiny touch of cadmium red light. The fourth is viridian green with the same cadmium red light to slightly gray it. I find the fewer combinations to make grayed greens, the better. Usually I use nothing more than a good green with a good red. Sap green is a transparent or translucent grayed green with many uses. I depend on it. I've tried to get along without it, but I keep going back to it.

The next four mixtures on the chart are mixtures of sap green with cadmium red light in varying proportions from cool to warm. See how just two colors can make such varied greens. These two colors can be combined with other colors as well for even more variety.

## MIXING YELLOWS

Indian yellow is my favorite and most used yellow. It is a transparent, vivid color that makes any color it is mixed with more vibrant and more beautiful. It can also be used as a glaze. In fact, any of the transparent colors can be used as a glaze. When a painting looks a little bit disconnected and needs to be tied together by a tone, I often take a very soft wash of Indian yellow and go over the entire painting, after it is dry, with just Indian yellow mixed in a soft medium. Copal painting medium light is a very good one to use with Indian yellow.

Next is Indian yellow plus Grumbacher Red. These very lively red and yellow hues combine to make a glowing orange. I use this particular color often in the centers of flowers and also more generally in paintings with a salmon tone or yellow-orange or red-orange flower.

Next is Indian yellow plus a tiny touch of ultramarine blue. This gives a slightly green-toned yellow, but it also has a soft gray look. This mixture is very useful when a softer, grayer tone is needed in a yellow flower or in any area where yellow needs to be slightly grayed.

Next is a yellow-green mixed from cadmium yellow light plus a tiny touch of cerulean blue that resembles lemon yellow or a cooler yellow. This can be mixed in a large pot and dipped into for other mixtures.

## MIXING REDS

Alizarin crimson is the red I use most. It is a vibrant red-violet that makes a beautiful base for almost any red flower. On the chart on the next page, I show this color mixed with a small amount of white so you can see how beautiful it is in its own right.

Next to alizarin, I have placed Shiva red crimson. It is slightly grayer than alizarin crimson, and it has just a slightly different hue. I like them both. Though I prefer alizarin crimson, I do use Shiva red crimson often.

The next red is Indian yellow with alizarin crimson. This combination is used for salmon-colored or more orange-colored roses. It almost glows, it is so bright. Because of the transparency of the Indian yellow and the alizarin crimson, this combination cannot be matched. I often use this deep in the centers of roses or the centers of other flowers, and sometimes over an entire flower.

The next color on the color chart is Weber Floral Pink, a premixed color. I have added white to this to show you its versatility without mixing it with another hue. It is a very pretty soft pink that has a glowing quality.

Next to it is Grumbacher Red plus white, and there is very little difference between them. I find that having the Weber Floral Pink already premixed is sometimes very handy. I prefer having this along with my Grumbacher Red for highly intensified red-pink touches on my flowers.

## *Mixing Reds*

Alizarin Crimson

Shiva Red Crimson

Indian Yellow
Alizarin Crimson

Weber Floral Pink
White

Grumbacher Red
White

## *Mixing Blues*

Thalo Blue
White

Thalo Blue
Grumbacher Red
White

Thalo Blue
Thalo Green

## MIXING BLUES

So often when I am painting florals, I have vases or pitchers or sometimes even flowers that require a very vibrant or strong blue hue. For this I use thalo blue straight from the tube. I use this color in many of the paintings throughout the book.

The next color on the chart above has a touch of Grumbacher Red added to the thalo blue. This is a very soft blue-gray. I wanted to show you the opaque quality when white and Grumbacher Red are added to the thalo blue. This is often used throughout a floral painting. It is a very good combination.

The third blue is a mixture of thalo blue and thalo green to make a more turquoise blue. This has many uses in painting plates, vases, cups, and so on. It is often necessary to use this very intense blue.

# *Mixing Violets*

Bellini Cobalt Violet

Grumbacher Cobalt Violet

Thalo Blue
Alizarin Crimson
White

Alizarin Crimson
Ultramarine Blue
White

Cerulean Blue
Alizarin Crimson

Sap Green
Grumbacher Cobalt Violet

Bellini Cerulean Blue
Bellini Cobalt Violet

## MIXING VIOLETS

The first violet on the chart is Bellini Cobalt Violet. I have used this rich violet hue for many years and love it. A beautiful violet is almost impossible to get from the three primaries. I find that even if I paint entirely from the perfect three primary colors—Grumbacher Red, cobalt blue, and cadmium yellow light—it is still almost impossible to come up with a beautiful violet mixed from Grumbacher Red and cobalt blue. Bellini Cobalt Violet is a must on my palette.

The second violet on my chart is Grumbacher Cobalt Violet. It is softer, grayer, and more opaque than Bellini Cobalt Violet. This color also has many uses, but when I need a good, strong violet, Bellini Cobalt Violet is my usual choice.

Thalo blue and alizarin crimson make a beautiful, dark, rich violet where a deep intensity is needed.

When alizarin crimson and ultramarine blue are mixed, there is less intensity of hue and a softer gray. There will be times when you need this grayer violet. It is a good combination for a strong, dense dark within foliage.

Cerulean blue and alizarin crimson make a rich dark violet. This mixture is great where density is required.

For a very good dark gray, I use sap green and Grumbacher Cobalt Violet. These combined in equal amounts yield a very soft, warm gray for deep darks or, with white added, a lighter gray.

A beautiful blue-violet is created when Bellini Cerulean Blue and Bellini Cobalt Violet are combined. I use this combination often for reflected lights and to add punch to a painting when I want to make it a bit more vibrant.

## Mixing Background Grays

Viridian Green
Alizarin Crimson
White

Sap Green
Cadmium Red Light
White

Viridian Green
Alizarin Crimson
White

Sap Green
Cadmium Red Light
Bellini Cobalt Violet
White

Sap Green
Grumbacher Red
White

Sap Green
Cadmium Red Light
Ultramarine Blue
White

## Mixing Whites

Pure White

White
Cadmium Red Light
Cadmium Yellow Light

White
Cadmium Red Light

White
Cerulean Blue

## Mixing Whites in Shadow

White
Ultramarine Blue
Cadmium Orange

White
Cerulean Blue
Bellini Cobalt Violet

Ultramarine Blue
Cadmium Red Light
White

Grumbacher Red
Ultramarine Blue
Sap Green

## MIXING BACKGROUND GRAYS

Backgrounds have plagued painters for years. They never seem to know how to mix the correct gray for certain backgrounds. I am going to describe a few of my favorite color combinations and explain when I use these particular colors.

The first background gray on the chart at left combines viridian green and alizarin crimson. This color can be adjusted to a warmer hue by adding more red and less green, or the reverse for a cooler hue. The color is clean and very vibrant. I suggest that you use this when a painting is cooler in the background. If a painting has a lot of cool blues in it, let's say, you will need to warm the background slightly in order to show the necessary contrast. This gray can be adjusted beautifully to slightly warm or to show a little more green. This color will remain cool, though; I still do not consider it a warm gray. If you wish to warm it up, I suggest you add a touch of cadmium red light.

The second combination for backgrounds is sap green and cadmium red light. This is a warm soft gray that can be cooled slightly by using a bit more of the sap green than the red. But it will always be warmer than the viridian and alizarin and should be used where a warmer gray is necessary.

The next combination on the color chart is viridian green and alizarin crimson, with a higher percentage of the alizarin. This gray is a very good all-purpose gray mixture to use when the painting leans slightly to violet as it has a somewhat violet cast.

Sap green, cadmium red light and cobalt violet were used for the next soft gray. This has many uses for background grays and can be combined with other grays.

Sap green and Grumbacher Red make a good all-around gray mixture. It also has a slight violet cast but is still warmer than the other grays and can be used where a warmer gray is needed. It can be made warmer yet by adding cadmium red light, though it will remain a gray.

The last gray is sap green, cadmium red light and ultramarine blue. This is my favorite background gray. I find this easiest to adjust because of the three colors used. To go warmer I use more red, less blue and green.

To go cooler, I use more blue, less green and red. It is a very useful gray for almost all combinations of colors.

## MIXING WHITES

Whites should never be used right from the tube. White as it comes from the tube is very chalky and needs to be enhanced with either a warm or cool color. I placed four blobs of pure white as it came from the tube on a dark background.

I then added tiny amounts of several colors. The second one is tinted slightly with cadmium red and cadmium yellow. This is what I almost always use when I want to get a more vibrant white.

The third shows cadmium red light by itself without the yellow, giving a soft pink glow to the white.

The fourth one shows a touch of cool. For this I used cerulean blue—a very tiny amount added to the white. The important thing when painting white is to keep the white as clean as possible. If you add these colors with a very clean brush to a very clean white, you can get a beautiful vibrant light. If either the brush or the white is even slightly dirty, you are going to get mud, I promise you.

## MIXING WHITES IN SHADOW

White in shadow can be very exciting or just dead. Here are four combinations of shadow whites that I use. For the first, I mixed ultramarine blue and cadmium orange plus white. This is a neutral soft gray that can be adjusted for temperature.

For the next shadow white, I used cerulean blue, a tiny touch of cobalt violet plus white. This is used more often for reflected lights than for shadow tones but can also be used in shadow where a very intense blue-violet is needed.

For the next one, I used ultramarine blue plus cadmium red light mixed with white. This gives a slight violet tint to the shadow tone.

For the last shadow white, I used a tiny touch of Grumbacher Red with ultramarine blue and a very tiny touch of sap green. This is almost a neutral gray. This combination works well when a little more violet or green or blue is needed.

# Painting Whites

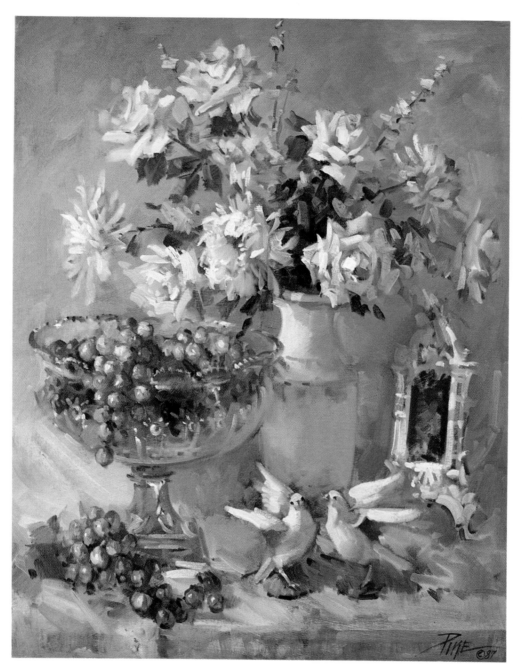

### ◄ *Crystal Bowl, 30 × 24*

A high-key, all-white painting is one of the most exciting subjects for a floral painter. White is never colorless nor is it without many subtle value changes. Therefore the decisions you have to make with a white subject are really the same as those for any other subject: composition, color temperature, value contrast, etc.

For this painting I chose a cool (blue) dominance. When I do a cool painting like this one, I usually use a warm acrylic wash on my canvas. As the cools are placed over the warm undertone, a subtle graying process occurs that becomes more lovely over the years. I use a soft scumbled stroke on the large gray background to allow the color to peek through and reserve the more intense hues for areas (such as the blue reflected light on the white vase) meant to draw the eye. There is no tube white here. Every white and gray has been carefully mixed not only for its value, but also for its temperature.

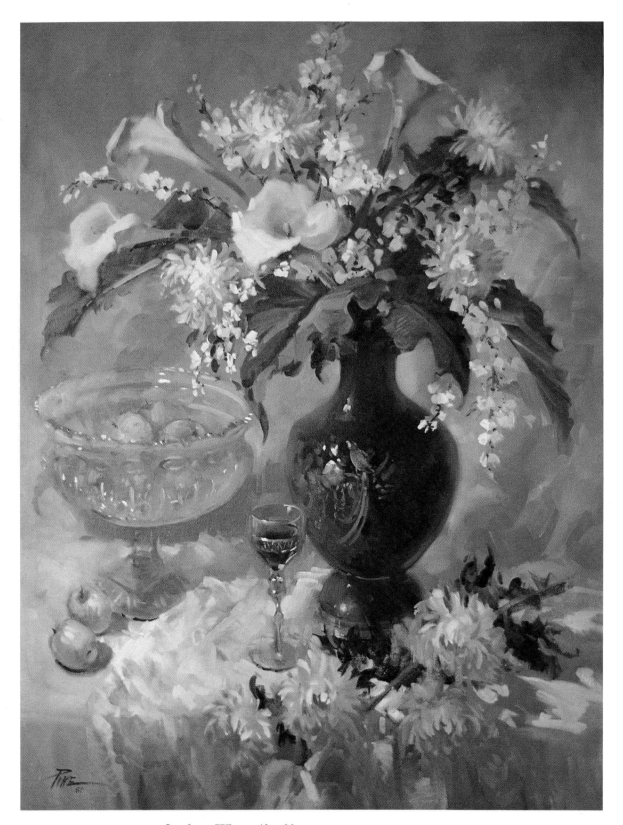

### ▲ *Study in White, 40×30*

This painting relies mostly on value, but the few touches of soft color give it a subtle richness. The dominant color of the painting is cool, so I put the yellow-orange fruit in the bowl as a complement.

My subject was mainly white, but some of that white was a value close to black. My grays were mixed almost entirely from ultramarine blue and orange.

# Preliminary Steps

*"To create form you must first think about mass without detail."*

Painting a still life can be likened to painting your house. Rolling on the final coat is easy and even fun. But if you fail to do all the preliminaries like scraping, sanding and cleaning, your final results will be mediocre at best and possibly worse than before you began.

In the same way, the preliminary stage of a painting—the planning—though it may not be as much fun as applying the final colors, is absolutely essential for good results.

If you do not feel just right about your setup, don't start to paint. Wait until you are completely satisfied with what you see.

I chose a middle to dark value for my background (actually, it is my studio wall). I chose it deliberately to act as a neutral dark for many of my setups. All three of the main objects—the candlestick, the clock and the vase—are of different heights and shapes. Once these

▲ Photograph of the setup.

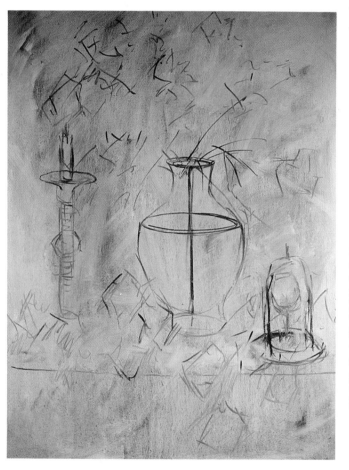

◄ *Step One.* I have a neutral gray background and my flowers are white. A white painting is never pure white but will lean to either a warm or a cool. I decide to go warm with red-orange as my dominant hue. I tone the canvas with an oil wash of Indian yellow and cadmium red light, grayed with cobalt violet using large loose brushstrokes—starting loose helps me stay loose throughout an entire painting.

I let the colors merge as I do not want strong colors or edges to disturb me as I plan my drawing and composition. I decide to make the white flowers stand out, with everything else going darker and grayer. I start drawing with the table edge so I will know where to place the objects. The center line, or plumb line, is placed through the center of the vase to make sure the vase stays straight and to help me place in the ellipses, even if I won't see an ellipse after a vase is painted.

three objects were placed in my setup, I could balance my flowers on the table to work with the objects. I placed the table edge a bit higher than usual and let some of the flowers overlap the sharp edge. I placed my spotlight at a perfect angle to cast a just-right shadow—not too long and not too short. Though it took a few extra minutes to get the spotlight right, it was time well spent. Once I was satisfied with my setup, it was time to get started with the painting.

## PRELIMINARY STEPS

1. Choose your flowers and objects.
2. Arrange the objects. This includes the lighting and composition.
3. Determine color dominance (warm or cool).
4. Determine value dominance (mostly dark or light).
5. Scrub in the undercoat.
6. Get your drawing correct.
7. Develop the correct colors and values.

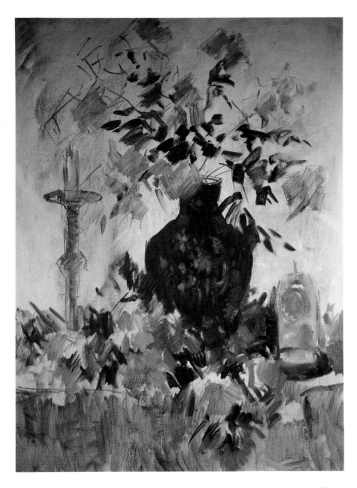

▲ *Step Two.* I now work out the color and composition by securing my darks and midtones. Without effective darks, my lights will be nothing. Mixing thalo blue, alizarin crimson and black, I place a thin layer of paint over the entire vase. Then I wipe out the pattern on the vase using my forefinger and a clean cloth. I add the shadows with a gray mixture of ultramarine blue and cadmium red light.

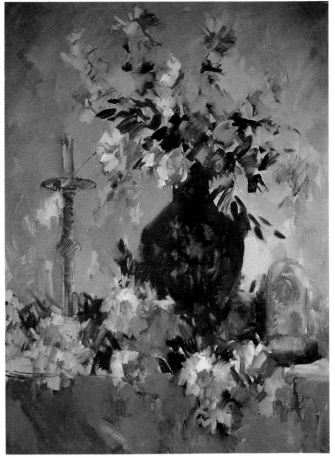

▼ *Step Three.* For the background I mix a gray from ultramarine blue and cadmium red light. I add white until I get the correct value. Using a scumble or scrubbing stroke, I paint over most of my original wash, allowing some of it to show through. The final effect is of a soft glow around the black vase. At this stage, all my darks and midtones have been completed. The preliminary work is done.

# Design and Composition

*"Flowers in a bouquet are like actors on a stage: Some must command more attention than others for a balanced performance."*

Design means making sure all the elements are placed in the correct spot to balance perfectly on the canvas. Either the darks or the lights should predominate; they should not be in equal proportion. The midtones need to support the darks and lights, the values merging in some areas to offset where the darkest dark and the lightest light come together to make the focal point. The strongest contrast will draw the eye first, before it starts its visual trip through the canvas. As I said in the beginning, everything needs to work together to make a perfect balance.

## DESIGN FOR "THE PORCELAIN PITCHER"

Working out the composition of this painting was fun because I planned to use a limited number of lilies with no supporting flowers. I decided on a busy background to contrast the stiff, harsh look of the lilies. Placing the decorative pitcher in front of the white vase helped to balance the long narrow canvas. The dark pattern of the large green leaves needed another dark for balance, so I placed the ginger jar behind the white vase. Had I brought the dark ginger jar to the front and the decorative pitcher to the back, the dark vase would have drawn the eye toward the bottom of the canvas.

I used a halftone on the left lower corner to break up all the light on the tablecloth. The cast shadows on the right side break up the negative space there. Remember, cast shadows are a very important part of the painting. But don't get too complicated with shadows at first.

The painting is warm and high key, more light than dark. The midtones play a more important part here than in most paintings because of the decorative midtoned background. Even though the pattern on the pitcher is subtle, it helps draw the eye back from the busy background to the lower front of the canvas. Everything I do has a purpose. I spend time planning every element before I start to paint.

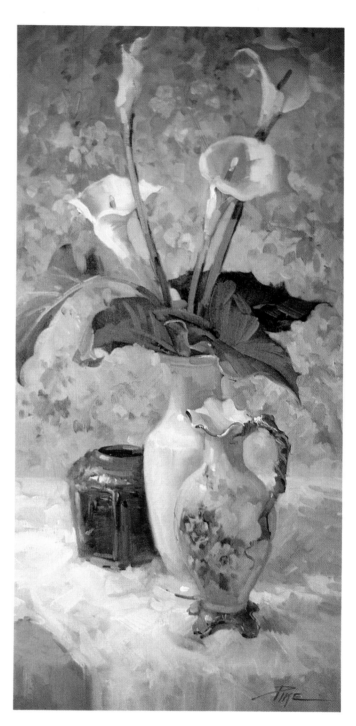

▲ *The Porcelain Pitcher,*
*30 × 15*

The busy background here offsets the stiff, formal lilies.

## DESIGN FOR "TULIPS AND SWEET PEAS"

A good painting need not be a busy one. Here I have used some beautiful fresh tulips, each shown at a different angle. The tulips to the left bend gracefully to allow the eye to travel downward from the center tulip. The dark vase is softened by the wild sweet peas, which are of the same dark value and color. The white cup with the cobalt blue pattern provides variety and also works to break up the hard edge of the very dark blue vase. I put a tiny blue duck in front of the vase to vary the hard edge where the dark vase sits on the white tablecloth. The two full-blown tulips in the direct center show foreshortening. This gives the illusion of three dimensions on a two-dimensional surface. The two petals from a spent blossom and the draped sweet peas help complete the design and break up negative space. The painting is simple yet effective.

Let's talk briefly about color. The overall hue is blue, with blue-green and blue-violet as adjacent hues and the yellow of the tulips as the complement. It is easy to see that the painting is high key. The dark purple of the vase works as a strong dark, and also supports the dominant hue. The overall look is cool, with just enough warmth on the tablecloth to break up all the cools.

▶ *Tulips and Sweet Peas,*
*24 × 18*

This simple composition is fresh and vibrant with its bright complementary colors.

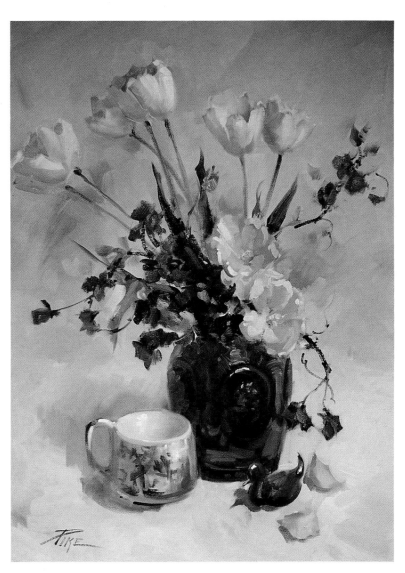

# Fruit with Luster

This painting is just the opposite of the last two. It is busy with lots of fruit and flowers. Color also obviously commands attention. What do you do when your subject is bright and colorful? How much can you safely say without becoming gaudy? As I arranged the setup, I planned a table full of cut and whole fruit placed in a relaxed setting. With so much color in the fruit, I would need strong color in the flowers. The one luster is ruby glass under an overlay of white porcelain. When the design was etched in the glass, the red showed through, making the luster a gaily decorated piece of art glass.

In the finished painting, unity is achieved by tying together the values and colors. The darks in the fruit tie together with the darks in the foliage. The color is strongest in the fruit, making it delicious to look at. A few flowers merge with the background, allowing the ones around the focal point to come forward. The white vase and luster merge slightly with the background. They are softened, yet still visible. Touches of the fruit colors are seen in the flowers and background and vice versa. The brushstroke is loose and direct everywhere except where I intend strong detail. When I finished, I felt good about my color and composition. Compositions do not always need to be strong and glaring; subtle compositions can be even more exciting.

▲ *Step One:* Because I intend to use bright colors, I don't want a wash or a toning, but go directly to areas of thinly applied pure color. This helps me see how the colors will relate in the finished painting.

▲ *Step Two:* I establish my composition by securing all the dark patterns. The easiest way to see where you are going is to work out the color and composition first, before you consider detail or finishing.

▲ Photograph of the setup.

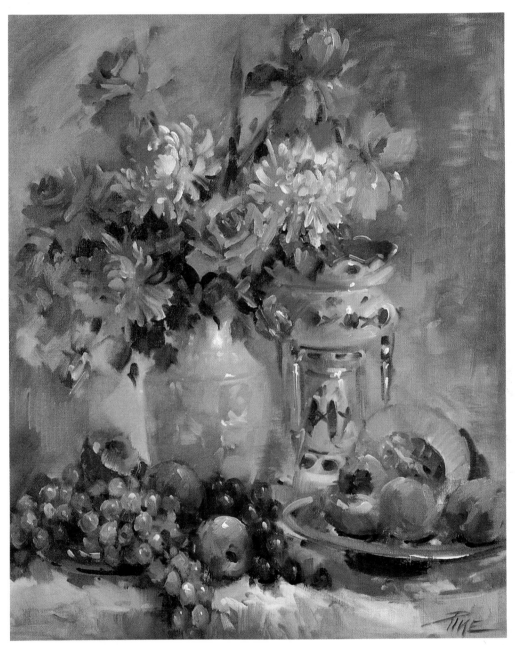

### ▲ *Fruit with Luster, 24 × 20*

Each object is carefully placed so detail work can be started. I keep stepping back to take a good look at what I am doing to make sure I do not go too far. The painting is alive with color, warm dominating over cool. Brushstrokes maintain the busy look I wanted. Note the focal point: The strongest dark and light contrast is where the dark foliage is near the light flowers.

# Drawing and Perspective

*"Draw just enough to know where you are headed."*

When a setup contains several objects of different size and shape, it is of utmost importance that every object be drawn correctly. I have chosen a clock as one of my objects to show you how carefully I draw each line and angle. I have also drawn every elliptical shape on each object as it would be seen from eye level. Once eye level has been established, all ellipses will become deeper the farther from eye level they are. This is clearly seen in the drawing. Each object is drawn in correctly to make sure I have enough space for all of the other objects. As we explore the use of perspective in our drawing, you will see that it is just as important to use correct perspective in a painting of flowers or still-life objects as it is for a landscape or city scape. Each object or flower can be simplified to one of the basic shapes, such as a circle, square or triangle. Ellipses are probably the most important shape for the still-life painter to master. Every rounded object becomes an ellipse when seen in perspective. These ellipses must be correct in order to show each round or oblong object from the proper angle, as most setups are viewed at an angle, not from above or straight on in one-point perspective.

## DRAWING FOR "BLACK ANTIQUE CLOCK"

After I suggest the placement of objects with light washes, I start my drawing by building a box in perspec-

▲ Photograph of the setup.

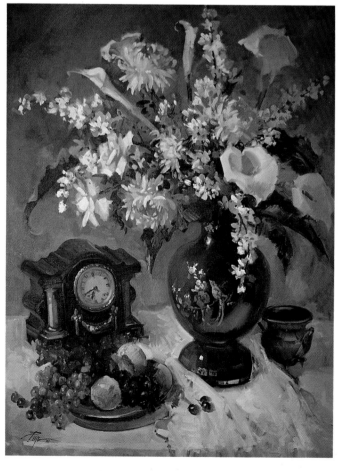

◄ *Black Antique Clock,*
*40 × 30*

A solid painting begins with an accurate drawing.

tive where the clock is to be placed. I then draw a plumb line through the center of the area where the vase will be drawn and draw the foreground dish, checking the measurement of height relative to width. This gives me the correct angle for placing my ellipse. The dish will have the deepest ellipse because it is farther from eye level. The way I measure width against height is to stand in one spot in front of the subject, hold my brush out straight and horizontally, and lock my elbow to be sure I don't move — if I move even a tiny bit, I could get an incorrect reading. I hold my thumb on the brush handle. From the tip of the brush to where my thumb is placed will give me the width reading. Now by turning the brush and taking a reading of height without moving my thumb I can see how much smaller the measurement of height is relative to the width. This is called a rule of thumb (that's where the old term came from). After I correctly build the box for the clock using two-point perspective, I then find the center of the box by drawing an "X". Once the center is located, I will know exactly where to place every part of the clock. This drawing procedure makes even the most intricate object easier to draw. The flowers need not be drawn as individual shapes at this time, but the suggestion of their placement is important for color and value. Not so with the still-life objects; they need to be carefully drawn right from the beginning.

▶ Adjust your drawing until it is right. And watch those ellipses!

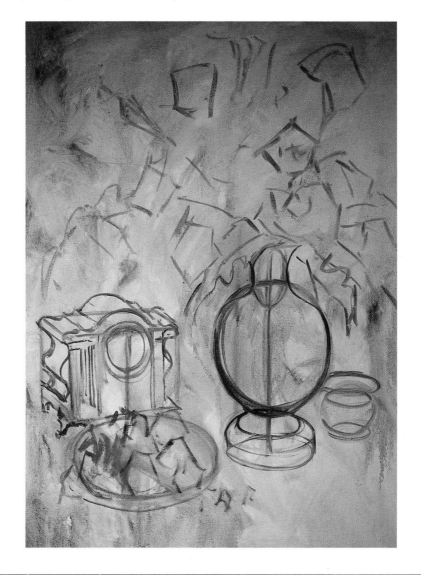

# High Key—Low Key

*"The key of your painting can set its mood."*

The decision to make a painting high key or low key should be made at the very beginning. Most of the time even your choice of objects will be affected by the key of your painting. Certainly this decision, like choosing a dominant color temperature, needs to be made before the first coat of paint goes on.

High key means the painting is light with a small amount of dark. In a high-key painting, the dark will draw the eye because of all the light around it. Low key means that the painting is dark with a small amount of light to draw the eye.

Often people think of a low-key painting as one with lots of dark grays and browns, and a high-key painting as one full of color and light. I thought I would show

you two examples to challenge these stereotypes. Both are predominantly red. *Copper and Persimmons* is low key but rich with color. *Ballet Afternoon* is high key, very soft and almost gray.

## LOW KEY: "COPPER AND PERSIMMONS"

I had been given a basket of beautiful homegrown persimmons by my dear friend Mary Hartsell. The persimmons were ready to eat and were absolutely alive with color. The painting problem I set for myself was how to translate this sumptuous living color onto the canvas. I decided to use a rich, deep color scheme. I chose to stay low key so I could use all the richness of color I wanted. I got a large branch of pyracantha berries, which I placed across the mound of persimmons to break up some of the round shapes of the fruit. To complement all this

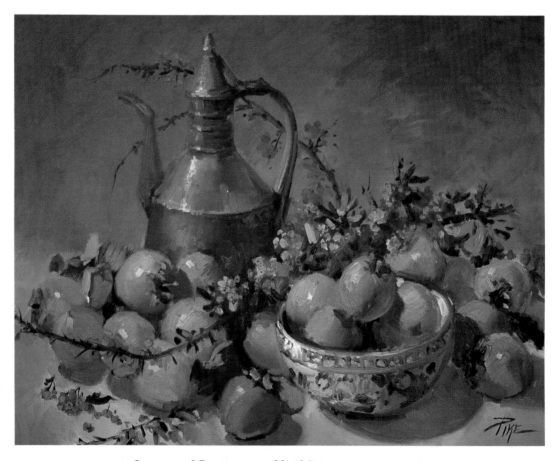

▲ *Copper and Persimmons, 20 × 24*

This is a low-key painting done in bright saturated colors with a red dominance.

orange, I added my cobalt blue, handpainted antique bowl. The focal point is small in this painting, where the deep red meets the highlighted edge of the bowl. With all this color, a large focal point is not necessary. To add vertical lines and break up negative space I placed the dark red copper urn in the background. It merged and worked well with the low key of the colorful fruit. My intention from the beginning was to make the fruit look alive and edible. Maintaining the richness of abundant, fully saturated color was one way to accomplish this.

## HIGH KEY: "BALLET AFTERNOON"

I wanted this painting to read like a snow storm with subtle value changes and delicate blossoms cascading almost like snowflakes from a white vase. The violin and ballet slippers are there to tell a story, but they are also an important part of the composition. Contrast with the overall high key of the painting makes the dark violin the center of interest. The ballet slippers are so light that they become part of the surrounding area but are still there to be part of the story. One of the most wonderful memories I have of visiting New York is of going to the ballet. The violin music was a beautiful part of *Romeo and Juliet* so many years ago. Whatever their literal meaning, objects are usually placed to break or create a line. The candlestick, vase and decanter were used for that purpose. The dominant color, red, appears in the pink tints of the blossoms and in the ballet slippers. Know your intention before starting to paint. Don't change your mind on either value (key) or temperature after the painting is started.

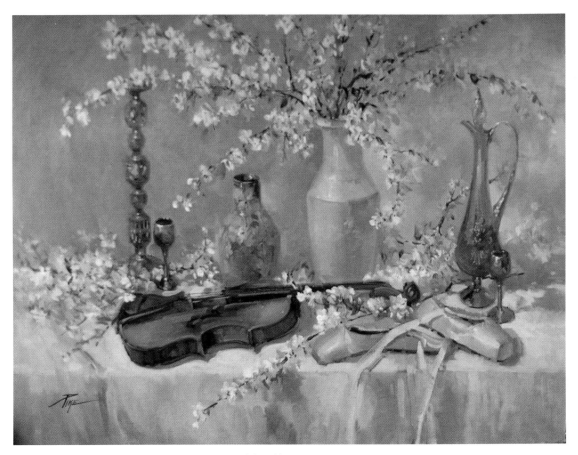

▲ *Ballet Afternoon, 30×40*

This high-key painting is also red dominant, but it is almost gray with delicate value changes.

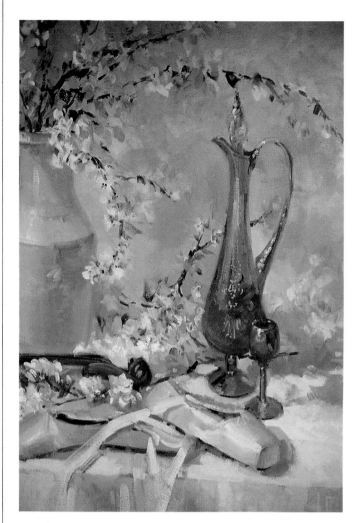

Details from *Ballet Afternoon*.

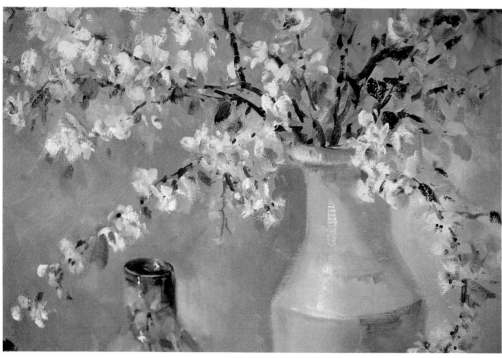

# *Using the Brush*

*"Your brushstroke is your signature. Know it well."*

## PRACTICING BRUSHSTROKES

How well you use your tools will determine how well you paint. Know them well. Below is a sample of my brushstrokes. For my most-used stroke, the scrubbing stroke, I load my brush with paint thinned to the correct consistency for my purpose. To cover larger areas, such as a background, I use a no. 10 or 12, flat or long bristle brush; each gives a slightly different finish. You will need to practice to determine what you want and where. Contrary to common belief, the best coverage occurs when the thin part of the brush is touching the canvas. One example shows a controlled drip, where a large amount of turpentine was mixed with the paint and allowed to pattern as it dripped down the canvas. This effect is interesting for distant areas and for some backgrounds. Leaves are often painted using a loaded no. 6 brush. I place leaves in a direct, straight stroke as you can see in the green area of the sample. For most leaves, I do not make a rendered shape but use this straight stroke. I have also shown you a more realistic leaf shape formed with a scrubbed stroke. Stems and leaves are best placed with a rigger.

## THE WHITE PITCHER

I can't be there with you in person, but I thought I would show you step-by-step how I would paint a single object, in this case an antique pitcher. It is very hard to describe a brushstroke, so I have included as many steps as possible so you can see how many brushstrokes add up to a finished painting. As you prepare to paint, you will need to follow a pattern; putting the cart before the horse can result in sometimes uncorrectable problems. Following a simple procedure can be timesaving and can prevent many problems.

▲ Here is a sample of my brushstrokes.

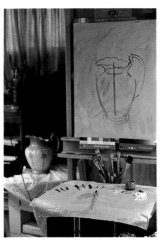

▲ *Step One.* First I scrub in a light tone with turpentine-thinned oil paint. The brushstrokes are purposely random at this point to provide a tone and a neutral foundation on which to build. With a small brush I then draw in the outline of my pitcher carefully, starting with the plumb line and being especially careful to draw the ellipses correctly.

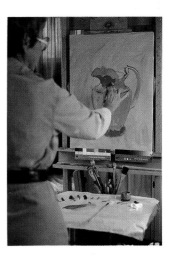

▲ *Step Two.* Next I softly hit the surface of the canvas with the brush bristles, adding darks and lights to the pitcher.

**▼ Step Three.** Holding my brush like a stick, I make a scrubbing stroke, keeping my hand and arm loose. My wrist also stays very flexible.

**▶ Step Four.** Using the same type of direct brushstroke, I apply the highlight with fairly thick paint.

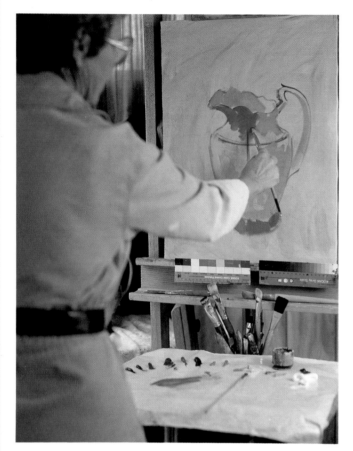

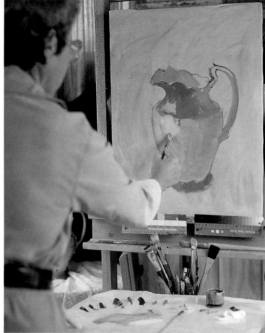

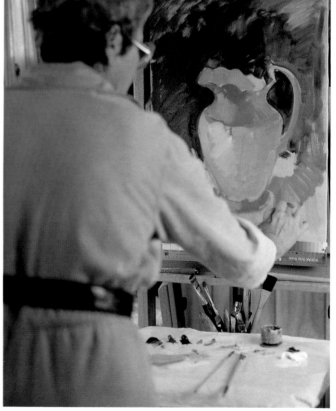

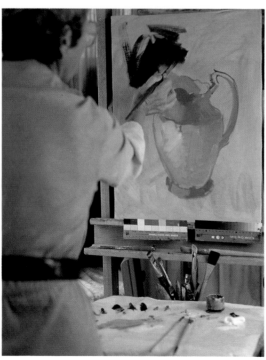

**◀ Step Five.** I load the brush with my dark mixture to apply the background with loose and easy strokes. As I do this I think about creating lost and found edges as this dark meets the light of the pitcher.

**▲ Step Six.** The shadow cast by the pitcher onto the white cloth is placed using a scrubbing stroke to utilize the full amount of paint in the brush.

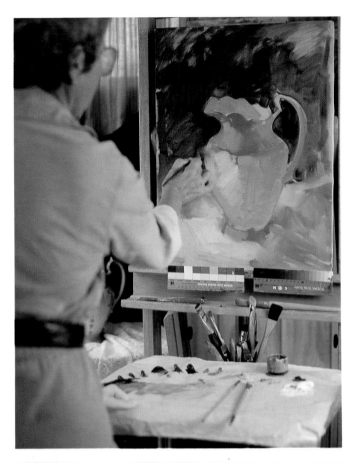

◄ *Step Seven.* Here you can see how I soften an edge to create lost and found brushstrokes. Don't be afraid to alter an edge you've already painted.

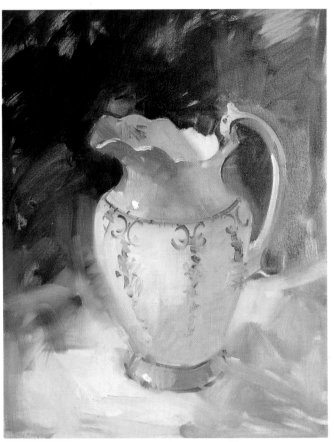

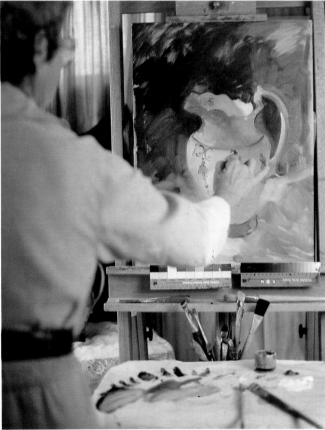

◄ *Step Eight.* To finish, I add the decorative trim using a thin application of Grumbacher Red with a no. 2 long bristle brush. I suggest only a few of the rosettes. If some of your lines are a little weak, don't worry. The eye can fill in softer areas.

▲ Practice subjects are just that. Don't try to make a finished painting—that would defeat the purpose of practicing. Here you can examine my loose, direct brushstrokes.

# Using the Knife

*"Knife work can liven up a dead area."*

Knife work can be added to any painting. It is a good way to make a strong statement. The knife can be used, often better than a brush, to apply clean paint over a spot of bad color. If you have painted a gray background and wish to break up negative space or just add more color, the knife can frequently do a more interesting job than the brush. For this I load my knife, place it directly on my wet canvas, and pull down or push up, taking the paint off the knife onto the canvas. If edges are a little sharp, I soften them by laying the knife flat and scrubbing lightly. This blends the edges into the background. I find it best to work wet on wet, but there are times when I like to add knife strokes over a dry surface for a beaded effect. Do this with one stroke—if too many strokes are placed in this manner, the effect will become too busy. You may find it necessary to soften some edges when knife work is added wet on dry as well. If so, take a brush and lightly soften where the knife and the brushwork on the background come together. Knife and brush can work together as a team. Learn to handle both and determine for yourself where each is best used.

▲ ▶ In this study, the loosely painted petals were placed in with both brush and knife. The initial lay-in was done with the brush, and a few overlaid strokes with the knife created some finished petals.

◄ Practice study of blossoms done with the painting knife.

▲ Most of the background was brushed on. The overlay stroke with touches of cerulean blue was applied directly with a knife and preserved by not over-mixing.

▲ Practice using the knife for flowers with only a few blossoms. First paint the darker center areas of the flowers with your brush. For this lily, I used alizarin crimson. Then I took my knife, loaded it with Weber Floral Pink plus a touch of white, and used a single direct knife stroke to create each petal. The brush was also used to suggest stems and leaves. A few finishing touches of the leaf pattern were added with a knife.

# *Understanding Color*

*"Choosing colors shouldn't be guesswork."*

Using color correctly can be as easy as 1-2-3, if a few simple steps are understood and followed. Even the novice can tell at first glance that a painting with color harmony is pleasing to view. The same novice can look at a painting with incorrect color and know something is wrong, though he may not know what. Before you teach yourself bad habits while learning through trial and error, take the time to learn the basics. I will introduce you to a simple yet effective approach to color.

The color wheel is made up of three primary colors — red, yellow and blue. From these three colors, all other colors derive. The truest red on my palette is Grumbacher Red. The truest blue is cobalt blue. The truest yellow is cadmium yellow light. These three colors are the primary triad and cannot be mixed from any other colors.

The three secondary colors are violet, green and orange. These are located between the three primaries on the color wheel and are called the complementary triad, meaning each is directly across from a primary and will be the one used to make grays with that primary.

Before you begin a painting, you must decide on a color scheme. The first question to ask yourself is, do you want a cool dominance or warm dominance? If you plan to do a cool painting, you can choose blue, green or violet to stay within the cool section of the color wheel. If you decide to go blue-violet and then change to blue-green midway through the painting, you are changing its dominant hue and therefore the whole color concept, because in choosing a dominant color you are also choosing a complement, the color directly across from it on the color wheel used to gray the dominant color and provide colorful accents. So it is important to be consistent.

### *Color Wheel*

This is not only my color wheel but also the majority of colors on my palette. I consider them my standards. Occasionally I will use a special color like Weber Floral Pink if a particular flower calls for it. Some of my students have told me that they cannot find Bellini Cobalt Violet or Weber Floral Pink where they usually buy their paints. If your local art supply store does not carry these colors, you can get them from Art Supply Warehouse, 360 Main, Route 7, Norwalk, CT 06851. Special colors can be helpful if used carefully, but usually I can mix any color I want from these twelve colors.

1. Indian yellow
2. Cadmium orange
3. Cadmium red light
4. Grumbacher Red
5. Alizarin crimson
6. Bellini Cobalt Violet
7. Grumbacher Cobalt Violet
8. Cobalt or ultramarine blue
9. Cerulean blue
10. Viridian green
11. Thalo yellow-green
12. Cadmium yellow light

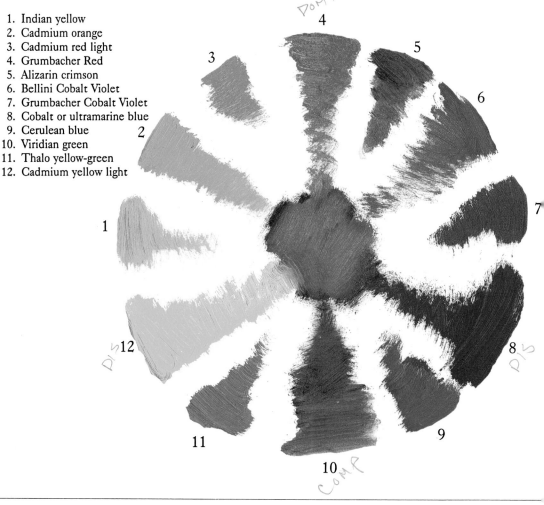

You should always keep a color wheel in your work area to plan correct color harmony. As I have always said, "When all else fails, follow the directions." When I plan a painting, I often place my selected colors on a cardboard color wheel. By eliminating all the other colors on the wheel, I am not tempted to stray. And it helps me know exactly how much of each color should be used for a perfect balance. Every painting will have both warm and cool in it. If the painting is warm, the cool will be seen in the grays and possibly in a touch of complement added for sparkle. The discords (colors on either side of the complement), if used, should be used sparingly and in equal amounts. These concepts are not complicated, yet they are ignored by many.

### ◄ *Study in Pink, 24 × 20*

I picked this painting to show you color harmony. This painting was done on heavy Masonite and has a rough texture. Each brushstroke was direct—placed on and left alone. The dominant hue is red, the adjacent hues (next to the dominant on the wheel) are red-orange and red-violet. The complement is green, seen throughout the painting in the grays. The discords, used in equal amounts, are yellow and blue. The painting is warm with beautiful vibrant grays. The thrill for me is in doing it correctly the first time. You can, too; just plan before you start your painting.

# Color Temperature

For each color denomination, there is a warm and a cool—for example, warm red and cool red. Generally, most opaque colors are warm and most cool colors are transparent. As we explore my palette, we will talk about the temperature of each color and how you can cool or warm it. First, imagine a line connecting yellow-green and red-violet and call it the warm-cool axis. On the left side of the axis are the warm colors, with orange the warmest; on the right side are the cool colors, with blue the coolest. It is easy to understand then that if a red leans more toward orange, it is warmer than if it leans toward blue. For example, alizarin crimson is cooler than cadmium red light. Grumbacher Red sits right in the middle and is the truest red. Cadmium orange is a very hot color, and if you wish to do a painting with a lot of orange but want to go cooler with it, Indian yellow will give a cooler, more yellow orange. In the same way, cadmium yellow light is a very warm yellow,

but if we add a little bit of green or use thalo yellow green, then we are cooling the yellow and moving toward the cool side of the color wheel. Viridian green is a transparent green and is quite cool. To warm it, we would add cadmium yellow light. The same general principles apply for the blues and the violets: Ultramarine blue leans a bit more to violet, making it slightly warmer than cerulean blue, which is on the cooler side of the color wheel; Grumbacher Cobalt Violet is cooler than Bellini Cobalt Violet, which has a lot of red in it—a very warm tone. If you are planning, say, a very bright red painting, but you want it to lean more to the cooler colors than the hot oranges, you would simply use reds from the cooler side of the color wheel. The point I wish to make is that a painting can be of one definite overall color yet still lean toward the cool or warm side of that hue.

▶ Think of the color wheel as being divided along a warm-cool axis, with orange the warmest color and blue the coolest. Any tube color can lean toward warm or cool depending upon which side of the hue it is on.

## Color Temperature

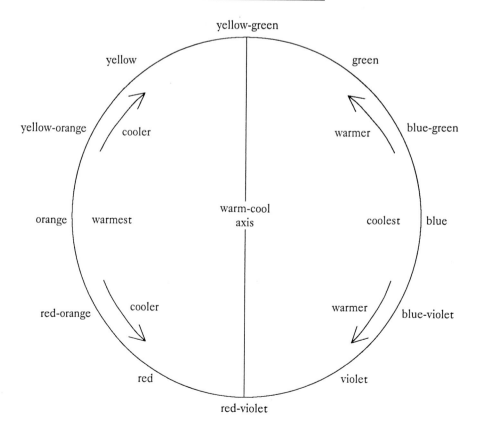

### ▲ *Mums with Candles, 40×30*

*Painting Cool.* This painting is cool, going from blue to blue-green to blue-violet. The grays are made from blue and orange. Only the dominant hue, adjacent hues and complement were used in this painting. Compared to the warm painting, this cool one is subtle and gray, with only a touch of pure blue. The beautiful part of painting is that you have a choice. It is your baby—you can do it just the way you want. You can choose to balance and plan for harmony, too. This won't stop creativity, only enhance it.

### ▲ *Oriental Vase and Blossoms, 12×9*

*Painting Warm.* To plan a warm painting you will start with reds, oranges or yellows. Values must also be planned from the beginning. This little painting is dark, with lots of hot colors in the vase. Even the blossoms have tints of warm pink. The white table is grayed and balances with the white in the vase opening. This painting works because both color and values are correct. By contrasting pure color with the background grays, I brought out the sparkling warmth of the Oriental vase.

# Color Comps

These three examples—two dark and one light—are what I call "color comps," or color compositions. They demonstrate the easiest way to plan both color and composition without getting caught up in subject matter. They are abstract and meant to be that way. If I were to go too far with detail or subject matter, I would defeat the purpose of preplanning. This is well covered in my book, *Oil Painting: A Direct Approach*, but I do want to touch on the subject here.

1. The first example is dominant red. The adjacent hues are red to red-violet to red-orange. The complement is green. The green complement is seen throughout the comp in a gray as well as a touch in pure form with white added. The discords are the two remaining primary colors, blue and yellow. They also are seen in small amounts and in pure form in the comp. By taking the time to work out my color and composition before I start to paint, I can avoid making mistakes that could mean a lot of wasted time or, even worse, a bad painting.

2. The second example is a light painting with only a small amount of dark. The colors I chose are yellow to yellow-orange to yellow-green. The complement of yellow is purple, and the discords are again the remaining two primaries, red and blue. Once I understand what colors I will be using in my painting, it is very simple to take a large brush or knife and adjust these colors quickly in this small color comp. This gives me a good idea of what I will be putting in my painting and helps me avoid mistakes in the actual painting. It is time well spent. As you see, there are grays as well as some pure yellow, but we see more yellow than anything else in this painting. I have used a small amount of dark, using both yellow and purple to create this gray. I have also used a small amount of red and some blue in pure form, but in equal amounts. This gives me a very good balance. I know I can use my adjacent hues as well as my main color, so I can go to yellow-green. I can also go to yellow-orange, which I have shown in this comp. The

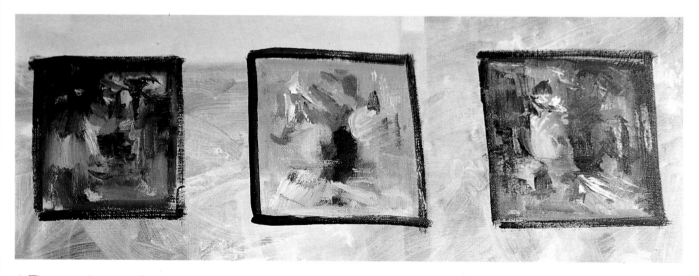

▲ These are color comps. I work out the color scheme of my painting using abstract forms before painting my setup.

composition is light overall with a small amount of dark, and the colors are working. Now I can approach my painting with ease, knowing exactly what I want to do.

3. My third example uses cool colors, more dark than light this time. I went dark enough with all of my blues and grayed them slightly with orange, their complement color. I also used a tiny bit of the remaining two primaries, yellow and red, that are also the discords.

In this example I also show where the complement, orange, can be used in pure form to add extra sparkle to a painting. By keeping my colors closely related to what I see on my color wheel, I can make everything come out correctly and have perfect color balance. The colors don't need to be placed where they are in the practice composition, but they do need to be in that color harmony and correct value.

▲ *Subdued Still Life, 30×40*

*A Neutral Color Scheme.* Painting with gray can be as exciting and challenging as painting with a vivid color. If your neutral painting is well planned, you can avoid mud or bad color. Remember that your dominant hue is not gray—it can't be. Every gray leans toward a color. My dominant hue here is red-violet; and yellow-green is the complement, used throughout the painting to gray the red.

# Background and Negative Space

*"Neutral grays may be the most important colors you'll learn to mix."*

Every inch of the painting has to work for you. You can't concentrate just on flowers and ignore the area behind them or in front of them. If a table edge shows, it is part of your composition and has to be carefully considered. If a background is flat and all one value or color, you will need to fill part of this area with flowers or foliage to make it work. I have chosen three finished paintings to illustrate this space-filling problem. Follow along with me as I explain my thinking.

## "COLORFUL FRUIT AND FLOWERS"

I had a bumper crop of beautiful, brightly colored roses. When I had everything ready to go on this setup, I put a 24″ × 30″ canvas on my easel. Then I just couldn't get inspired. I don't know why, but I never seem to get as excited about painting smaller paintings as I do about painting big ones. So I changed to a 30″ × 40″, my favorite size canvas. Now I had another problem: I would have more negative space in my background. What to do? The flowers were very colorful, so I used several colored grays in the background and allowed the brushstroke to show slightly. If I had used a neutral gray background, the flowers would have jumped out with all their color, which was not my intention. I wanted to keep it subtle, so I placed stronger color in my background.

## "HAPPY WANDERER"

This little 24″ × 18″ painting was done as a demonstration for my class. The matilija poppies and wisteria are such a beautiful combination. The floppy look of the

▲ *Colorful Fruit and Flowers, 30 × 40*

In this painting, the colorful background harmonizes with the brightly colored roses.

poppy and the graceful, draped look of the wisteria go together very well. The background is gray and almost flat, but the flowers take up most of the picture plane. It was not necessary for me to show brushstrokes or more color in the background here. The one small figurine left too much negative space on the table, so I draped the wisteria down to touch the table and scattered a few wisteria blossoms on the tablecloth. There are many ways to fill negative space. Those spaces may end up being relatively empty or full of objects, but you must make sure they work by planning your composition well. Don't leave it to chance.

## "VENETIAN GLASS"

Here we see flowers going to the edge and even a few going out of the canvas. When this is done, the background is almost nonexistent, evident only where it is seen around or through the flowers. The table is where I could have gotten into trouble. I didn't want the decanter and liquor glasses too close to the edge of the table—this would have made the painting appear to be cut down from a larger size. By placing the colorfully painted vase to the left, I could draw the eye down to the glasses—again, filling negative space. A little empty space is necessary. There should always be a spot somewhere, even if it is small, where the eye can go for a place to rest during the trip through the canvas. If composition is working properly, your background and negative space will be an essential part of that composition.

▲ *Happy Wanderer, 24 × 18*

The flowers take up most of the picture plane here, so it wasn't necessary to add much to the background.

▲ *Venetian Glass, 12 × 9*

In this painting the background was not a problem, but I did have to arrange the glasses carefully on the large negative area of the tabletop.

## "THE LIT CANDLES"

Here is a setup where I used a patterned drape behind my lilies. This is a fun way to put color and texture in your background. I have used the pattern in the finished painting but toned it down so that the lilies remain the stars.

The dominant hue is yellow, to yellow-green, to yellow-orange. The complement is violet or purple, seen in the cast shadows and throughout the painting as grays. The fruit goes to orange with touches of red and blue seen as equal discords throughout the painting. The background adds interest to the negative space without detracting from the lilies. Many times a slight texture or pattern in a negative area such as a background or lace tablecloth will take care of the problem of negative space.

▲ Photograph of the setup.

▶ *The Lit Candles, 40 × 30*

For this painting I used a decorative drape for color and pattern in the background. As you can see, I didn't copy it exactly.

► A close-up of the central flowers.

### ▲ *Lavender, Matilija Poppies and Hibiscus, 24 × 36*

In this background I echoed my cool dominant color with muted, darker tones. To add excitement I repeated the linear brushstrokes used in the flowers.

# Using Value

*"Value is the element that most determines your focal point."*

Use of value is the most important part of any painting. A painting with poor color and good value will work; a painting with bad value and good color will not. It is vital that you understand the use of value in a floral painting. For one thing, it is not possible to show perspective or dimension without it. More important, value is the essential element in determining focal point.

Generally, the area of a painting that has the darkest dark next to the lightest light will be your focal point. The location of this focal point should be determined during the planning stages, not halfway through the painting.

Once this point is determined, you are ready to plan all remaining values. You must never juxtapose this dark and this light again. The same degree of dark can be used somewhere else on your painting, as can the light, but they must not appear together. This makes all other value mixtures less intense than the focal point.

Overall, the values should be worked out so that there is either a strong degree of light with a smaller

▶ *White and Silver, 30 × 24*

In a "white" painting like this, value is crucial. If you look carefully, you will see that there is very little real white in the painting.

amount of dark or vice versa. Two-thirds dark to one-third light, or vice versa, is a good rule but not a hard and fast one. More light can be used with less dark, making the painting even lighter with a smaller amount of dark. But avoid going half dark and half light—this is unacceptable.

Another very important point is to be sure that when a vase is used in your setup, there is a sense of air or of space behind it by showing light continuing beyond the vase. This creates the illusion of turning. It is part of perspective and very important in floral painting.

## "THE FRUIT BOWL"

Most floral and still-life paintings consist of flowers and objects all working together for a perfect balance. Balance means that though all objects are different, they complement each other in a rhythmic way. This painting below is warm in temperature. The grays work to complement the warm hues of the flower and fruit. The painting is mid-to-light in value, with the eye going to the dark of the ginger jar. Darks and lights are placed to allow the eye to travel through the composition.

▲ *The Fruit Bowl, 30 × 40*

If you squint at this painting you will see an interesting pattern of light and dark. Though color is probably the first thing you see in this picture, it would not work at all without the light-dark value pattern.

# Light and Shadow

*"Look through half-closed eyes to help determine edge treatment."*

Understanding light is another aspect of creating depth that cannot be ignored. If you are painting indoors and have a warm spotlight on your subject, you will have warm lights and cool shadows. The shadows will appear to be cool when the lights are warm. If you are using a cool light or filtered light from a window, your shadows will appear to be warm relative to the cool light. In other words, to show the turning of an object there must be a reversal of temperature from the light to the shadow. It is never necessary to use drastic temperature changes — for example, to go from hot to cold — on an object such as a vase, but it is necessary to show the difference between light and shadow by subtly changing from warm to cool, or vice versa, to show an object's roundness.

## "EASTER BONNET"

I have chosen a light painting with subtle values. This painting was done indoors with a 100-watt spotlight,

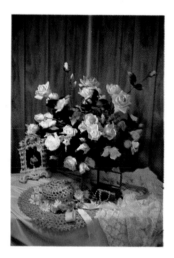

▲ Photograph of the setup.

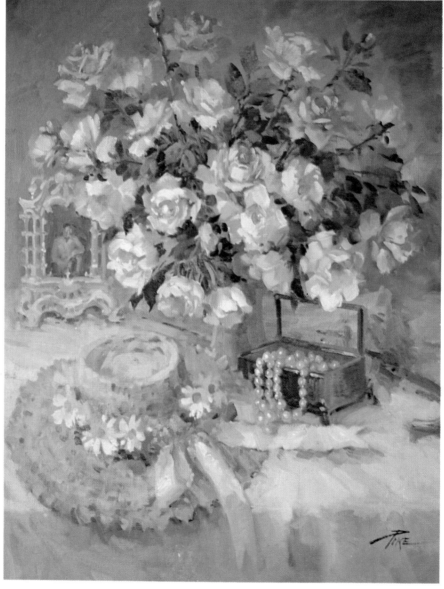

▶ *Easter Bonnet, 30×24*

When painting indoors I prefer subtle value changes. For *Easter Bonnet* I used just a 100-watt spotlight, adjusted to give me the shadows I wanted.

giving very subtle value changes, and I typically use subtle value changes when painting indoors. I prefer this to harsh shadows. Though I like softness in a painting, I also like some degree of contrast and show this contrast in the flowers and leaf pattern. Don't forget that the temperature of the shadow affects the intensity of the temperature of the light. Cool shadows intensify the warm lights.

## "SILVER AND BLUE"

In this painting, my table is higher on the canvas so I could show the table edge. The bouquet, chair, tablecloth, and flowers are all equally important parts of the composition. The direction of light creates shadows on the white that dominate the light areas and make a strong composition. Shadow whites can be more exciting than white in the light because of their subtle colors that range the entire spectrum. Darks are also important in making the lights work. The dark value in the background balances the darks at the bottom of the painting. Without the dark at the bottom of the painting, it would have been too evenly divided—half light and half dark.

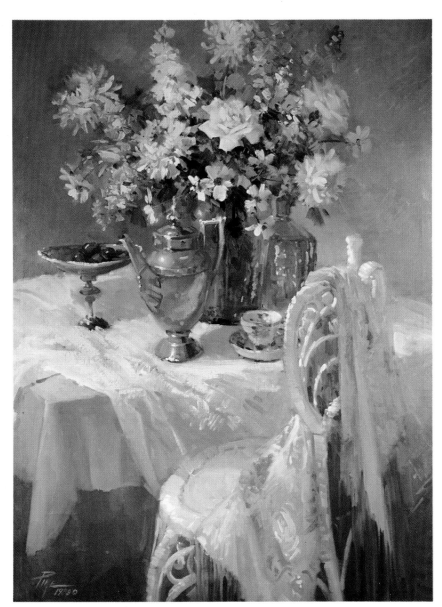

▶ *Silver and Blue, 40 × 30*

For *Silver and Blue* I arranged the light so that whites in shadow make up a large part of the composition. I find these subtle colors fascinating and beautiful.

# Painting Flowers Indoors

Flowers are beautiful whether in a fresh cut bouquet or growing in a garden or field. What makes a flower beautiful? Its glowing color and unique shape, and in some cases its pleasing fragrance. I have been told by some who view my work that my paintings are so lifelike, they can smell the flowers. This is a very nice compliment, but what is the reason for it? I would say it is because I paint life, not a photographic likeness. What makes my flowers look real? Is it the way I hold my brush or the way a petal is turned or stroked? No. When value and color come together in perfect harmony, the result is a truly lifelike appearance. As you study the process of painting flowers and still-life objects indoors, you will learn to see these values and colors. You might even get lucky and paint the fragrance.

# Collecting Still-Life Objects

*"Your choice of flowers and objects should be a personal expression."*

An artist cannot paint without his or her tools. If you plan to paint still lifes, your still-life objects become your tools. You shouldn't try to imagine the shape of an object without having it before you, any more than you would paint without your brush. Finding my goodies is one of my joys in painting. To me, garage sales and junk stores are like candy stores to a child. My junk is my treasure. Even if something is broken, I can still fall in love with its color, shape, history of artistic creation. I must admit, I have favorites, such as the crystal lusters that I have used in dozens of paintings. My studio is full of beautiful objects to choose from, yet I often reach for the same one again and again to make a composition work. This is nothing more than personal preference. As you select objects for your paintings, think about size, shape and color, but by all means let yourself be inspired. I see nothing wrong with painting something many times if you enjoy it, as long as you don't fall into painting the same subject over and over just because it is familiar to you. This is a bad habit and can keep you from growing.

Keep changing the objects in your setup until it turns you on and makes you anxious to get started—only a beautiful, inspiring setup will result in a beautiful, finished painting. Never try to force a tall, thin vase

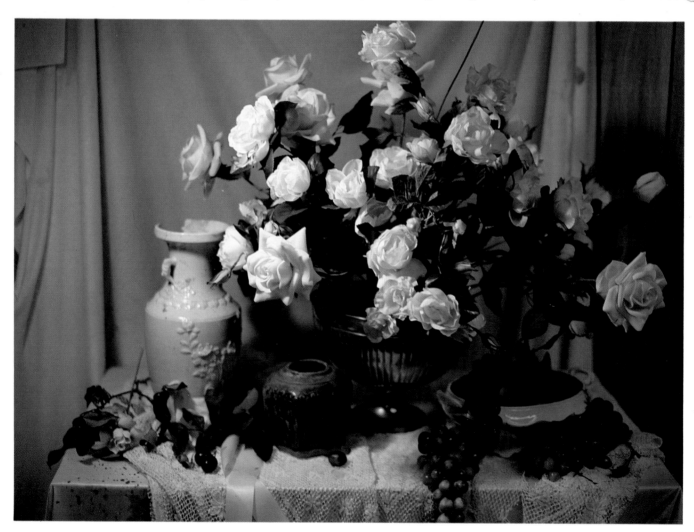

▲ Photograph of a setup with several of my "treasures" in it.

to work where a short, fat vase should be used. Plan for well-related shapes and color; it's more difficult to change a shape or color on your painting than to make your setup look right from the start.

If you decide to collect artificial flowers, be selective. Try to buy at least a few of better quality. Buy your silk flowers from several different manufacturers. It's also a good idea to mix real and artificial flowers. This will help your bouquet look more realistic. Shop around; have fun buying your flowers.

You can see in the demos that include a photo of the setup how carefully I usually stick to my setup. To me, collecting and setting up the objects for my still lifes is part of the creative act of painting.

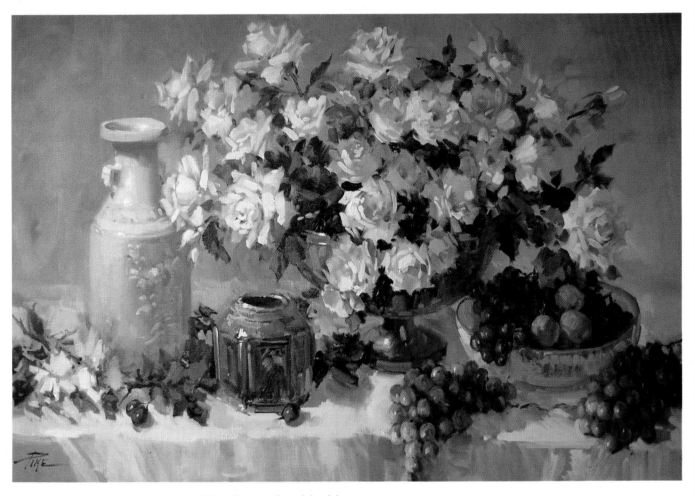

▲ *Blue Ginger Jar, 24 × 36*

Any object can be used in a painting as long as values are correct. I have successfully used several different objects in this painting by emphasizing some and understating others. See the demonstration on page 107.

# Arranging the Setup

*"Make the arrangement for shape and balance, not necessarily for subject matter."*

Every good painting starts with a good idea. Inspiration is important to the success of a floral still life, but inspiration alone isn't enough. The arrangement must be based on shape, color and balance. If you are using flowers, let the flowers take center stage. This can be done by making sure that all the other shapes are the right color and value for their intended spot. The light source is also a part of the composition. Where and how much light is striking influences the balance. Cast shadow is part of the lighting. Without the light, the shadow doesn't exist. The stronger the light, the darker the shadow. This dark and light pattern is the most important part of any painting and should be considered from the very beginning. Again, don't guess. Have everything well planned before you start.

All three examples shown here could make good paintings. However, example #1 seems a bit busy. Example #2 has good balance, but it is not quite as appealing as example #3. The key word is balance to make everything work.

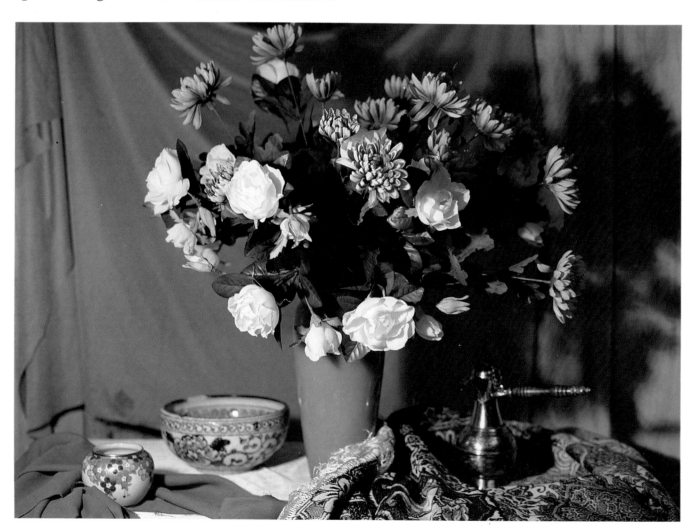

▲ *Example #1.* This has good color, but the objects are too far apart. The purple cloth at the left tends to make things a bit busy by covering up a needed resting spot for the eye. The small brass coffeepot server is lost in shadow.

► *Example #2.* With only a few minor adjustments, things start to improve. Overlapping the two bowls to the left makes that area less busy. Removing the purple cloth also cut down on clutter. The light on the white cloth brings the eye down from the light flowers.

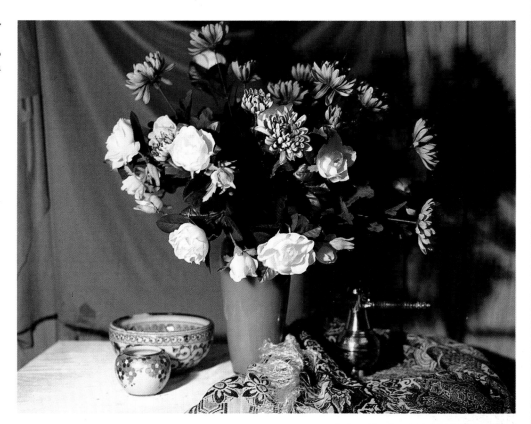

► *Example #3.* When I move the blue and white bowl to the right of the flowers, it makes a nice contrast with the dark spot behind it. Moving the coffeepot to the left, behind the small bowl, and allowing the handle to overlap the vase help break up the straight line of the vase. All the objects now balance better for several reasons. The dominant colors are blues and violets, but a bit of the complement can be seen in the decorative drape on the table. The small colorful bowl to the left brings both dominant and complementary colors to the left edge of the canvas. The larger bowl adds light and design in the dark area where it is needed to continue the path for the eye.

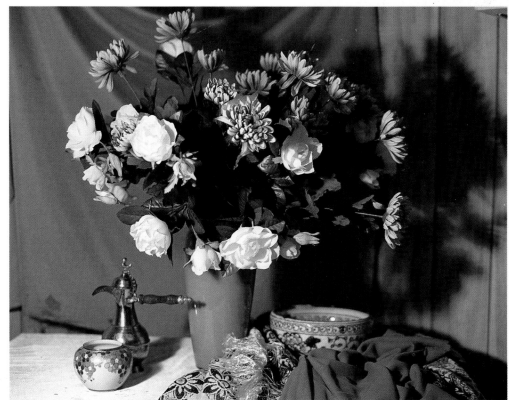

# Iris and Hat

▶ As I selected objects to go with a beautiful hybrid iris, I first considered color. I selected the blue-violet background drape and the blue Spanish shawl on the table. I used the pink ribbon on the hat and pink tones in the background to tie in with the light pink-violet iris and used three yellow iris in the bouquet as a complement. The gray-yellow hat repeats the complement. The jeweled box and pearls add animation by giving the eye a place to go.

◀ *Step One—Toning and Sketching.* A wash of dominant and complementary colors is applied using paint thinned with turpentine and allowed to drip. Tints of color are suggested where the objects may be placed. I allow the canvas to dry about fifteen minutes before starting my sketch. Then I sketch the placement of each major object in a simple but accurate drawing.

▲ *Step Two—Lay-in.* Each object is laid in according to shape and color without detail. A loose, direct brushstroke keeps things from looking finished too quickly. This lets me be more selective with detail and also allows me to make sure all colors and values are working.

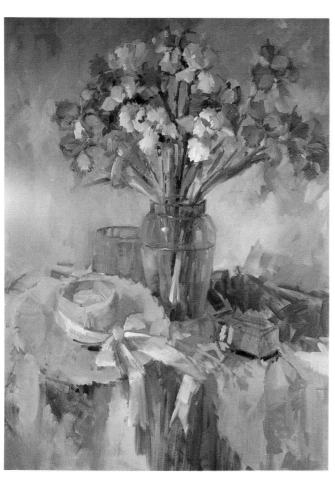

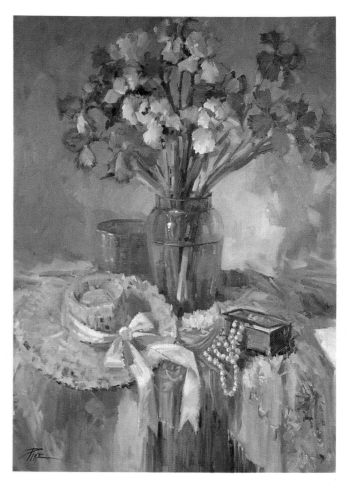

**▲ *Iris and Hat, 40 × 30***

The color and value balance are set. As long as I don't make major changes, I can finish as much or as little as I wish. At this stage, I step back frequently and take a good look. It's a mistake to start having such a good time that you forget to check how you are doing.

**▲ *Step Three—Selecting the focal point and relating objects.*** Your eye will go to where the darkest dark and lightest light come together. Usually, this should be within the floral arrangement. If all other objects are closer in value, this focal point can be seen first. I place in the light iris to be a focal point. Then I bring the eye down to the hat, then to the pearls, completing the trip through the painting. The drapes and subtle objects continue the balance of color or value.

# Pretty Bouquet

This setup was used for a lesson in one of my workshops. I chose a selection of several flowers to make up a pretty bouquet: mums, roses, daisies, and a few stalks of red-violet gladiolus, one in the bouquet and two on the table for color. The dark vase brings out the light of the small porcelain pitcher. In the photograph, you see a pink ribbon draped over the gladiolus that I chose not to place in my painting, although a few of my students did place it in with success.

► Photograph of the setup.

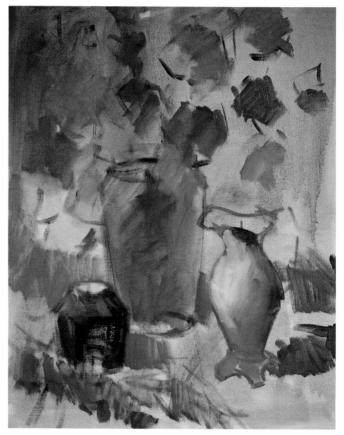

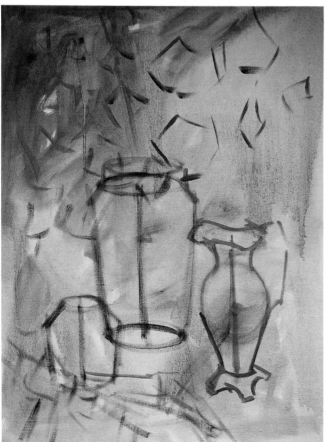

◄ *Step One—Toning the Canvas.* Toning the canvas first allows you to see relative values more clearly. Using ultramarine blue thinned with turpentine, I draw in the correct placement of each object. I use an oil wash of red-violet grayed with sap green. My dominant hue will be violet with only a touch of yellow complement seen in the centers of the daisies and used to gray all hues throughout the painting.

▲ *Step Two—Blocking in.* This is my favorite part of the painting process as it lets me see what the painting will look like when completed. The only thing missing is the detail. Each object is blocked in using correct color and value both in shadow and light, keeping shadows cool and lights warm. I always block in flowers with stronger and darker color to increase contrast.

### ▲ *Pretty Bouquet, 24 × 18*

Now detail can be added without changing established values or colors. I work first on the white daisies against the dark green foliage as they are my focal point. Then I develop each remaining flower relative to the daisies. Some flowers are only suggested. The vase holding the bouquet is almost lost to make the small blue-violet pot and porcelain pitcher come forward.

# *Choosing a Color Scheme*

*"Don't use every color on your palette for every painting."*

Choosing a color scheme can be the easiest part of planning your painting. The easiest method is to choose one color to be dominant over all other colors. Then you could also use the two hues adjacent to your dominant color on the color wheel and the complement located directly across the color wheel. This basically is all you need to decide.

If you feel your painting needs a bit more excitement or pizzazz, use the discords located at the two points of the triangle equidistant from your dominant color. These discords are best used pure and always in equal but small amounts.

Here's an example of a color scheme: If I choose to do a red dominant painting, I can use red-violet and red-orange as my adjacent hues. All three can be used as my dominant or main colors—not necessarily all mixed together, but harmoniously blended or left pure to show each hue. Green is the complement of red. A small amount of green can be used in pure form to add spark to the painting. All grays would be mixed from different amounts of reds and greens. I can't get carried away with green—it should never become as important as red or I'll have a split color scheme. I concentrate on red, red-violet and red-orange; they should dominate. Grays will pull everything together in this painting. Without the proper grays, I'd have a garish, bright red mess. To add pizzazz I could use a small amount of the discord colors, the other two primaries—blue and yellow, in this case.

On the next few pages are two small paintings I did as studies to show two opposite color schemes, one warm and one cool. Note how I get a broad range of values, as well as grays, yet still keep my painting warm or cool.

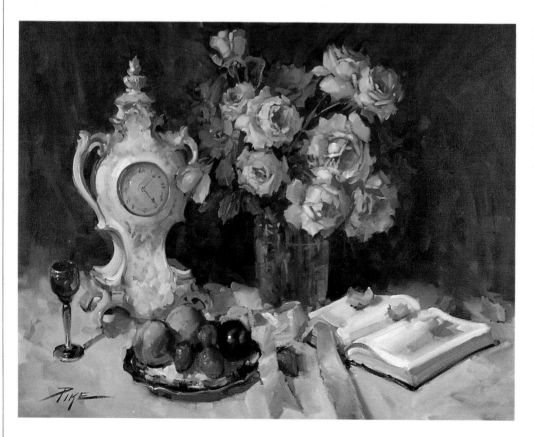

**◄ *Very Pink Roses, 24 × 30***

Roses can't get pinker than these, and the plate of fruit is glowing with delicious color. This was a perfect setup for a red to red-violet color scheme. Notice the greens used to gray the background and the red-violets used throughout the rest of the painting.

# Study in Warm

In this and the next demonstration I used a full range of color from pure color or chroma in some areas to grays or less intensified color in others. Value is always the most important factor in any painting, and for each study I used the lightest lights and darkest darks possible. It is always easier to see a light value if there is a dark behind it or vice versa, thus the reason for the dark background and light tablecloth. Pink is simply red watered down with white. I chose pale pink roses to make a strong statement against the dark background. The red vase is the hottest object in my collection. I needed one strong statement of color and it filled the bill. The small rose bowl in the foreground is a combination of both orange and blue flowers against white. The touch of blue adds a bit of complement in pure form to balance color harmony. Blue has already been used throughout the entire painting in the grays.

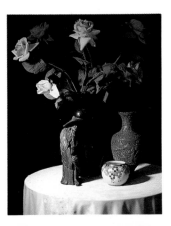

▶ The color scheme started with my choice of objects. I selected objects and flowers all within a red to red-orange color scheme.

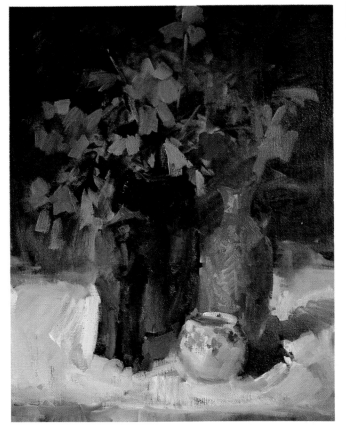

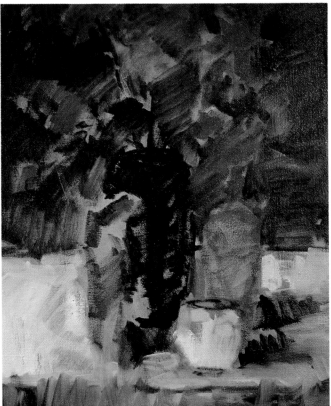

◀ *Step One.* I start with a yellow-orange toned canvas to intensify the bright colors that will be used over the tone. Each color and value is placed in correctly but loosely.

▲ *Step Two.* As I render each object, I am careful not to change value or color.

▶ See how little detail is necessary to make a statement?

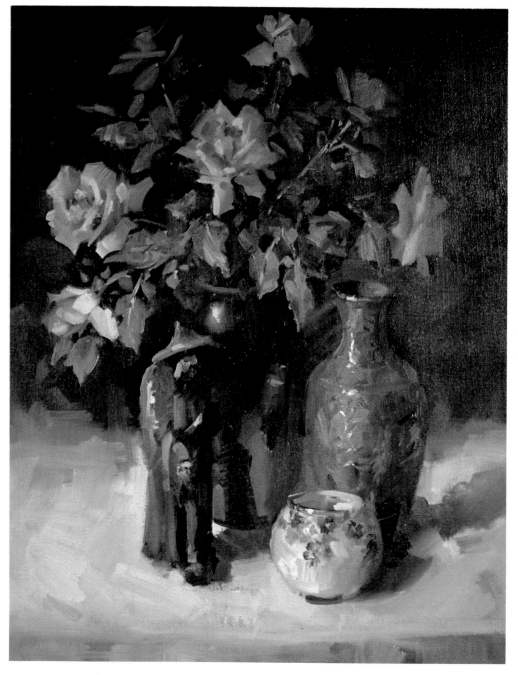

◀ *Study in Warm, 20×16*

Each color and value has a purpose. The pink rose against the dark background offers perfect harmony without detracting from the pure hot color of the vase.

# Study in Cool

Some of the same objects were used for this study in cool colors. For this I chose the blue ginger jar instead of the red vase used in the warm study. The white roses were a perfect value as well as color. White reflects the colors surrounding it, so white can be painted to go either warmer or colder depending on where it is used. It was very easy to cool these white roses slightly with blue. The dark delphiniums gave me another touch of blue against the dark background, but they did not take away the pure blue I wanted to keep in the ginger jar. The same Oriental figurine was used for both studies. In the blue study it is cooler. The rose bowl was also used for both studies. It combines both warm and cool and worked perfectly to incorporate a touch of the complement in both studies.

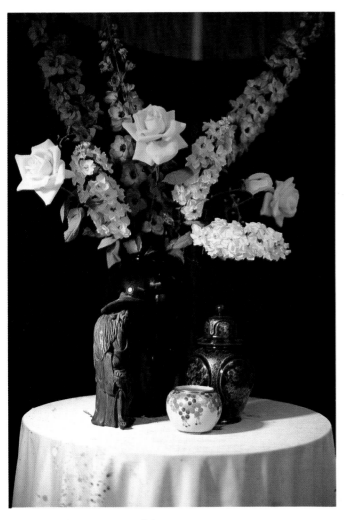

▲ I decided to use some of the same objects and an almost identical arrangement for my "cool" painting.

▲ Here I set the tone with a dramatic value contrast using ultramarine and only a touch of the orange complement to gray the blue where needed.

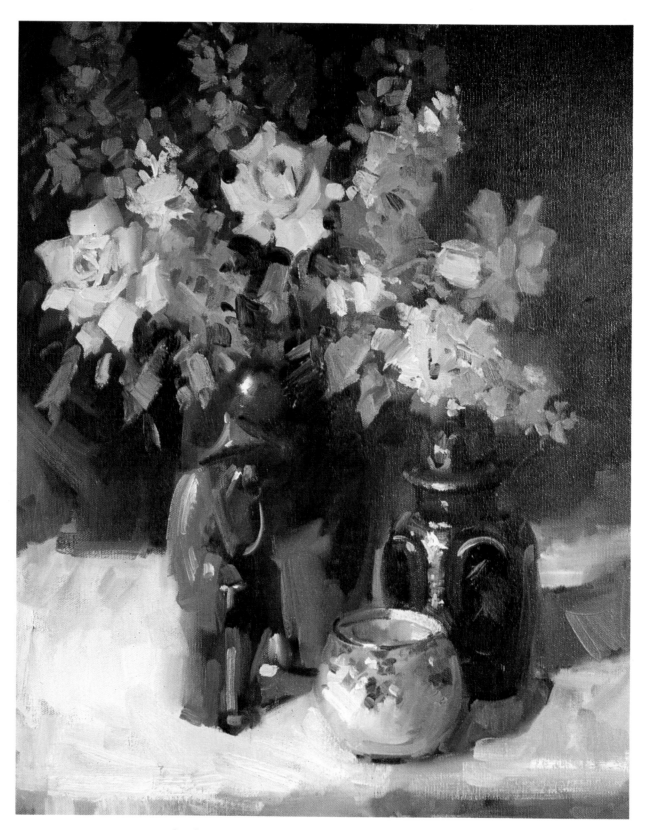

### ▲ *Study in Cool, 20 × 16*

In the finished study you can see how the cool color scheme makes
the feeling of the painting entirely different from the warm study.
The decorative pattern on the small rose bowl added a sparkle of
complement in both paintings.

◄ This detail of the flowers shows the subtle warm tones among the overall cool whites.

◄ Compare this detail with the similar detail from the warm study. Notice the subtle differences in color choices made in painting the same object.

# *Painting with Strong Color*

*"Exaggerated color can be exciting if well planned."*

There seem to be three schools of thought on color—some painters really enjoy strong color and tend to go close to pure color; some lean more toward grays; and some sit in the middle and enjoy both ways. All three can be correct if properly done—it is your choice. Strong color does not necessarily mean color straight from the tube. When I do my florals, I use pure strong color as an underpainting mainly to be assured of having the correct color after the grays are placed in over the glowing brilliant hue. This keeps my color clean and my flowers or objects looking alive. Grays are needed to quiet down some areas, allowing the brighter colors to achieve their intended vibrancy. Strong color against strong color would only be garish and confusing. And strong color does not necessarily mean dark value. Color can be strong or grayed (intensity); light or dark (value).

◄ You can use a medley of color in your setup as long as the colors balance and the painting leans to one dominant hue. Here I used salmon pink, yellow and pure pink roses in such a way that the setup sings. Once my flowers were arranged, I selected objects to balance the color and value, such as the red venetian glass decanter and the liqueur glasses. My dominant color is orange, going to yellow and red as adjacent hues.

▲ *Step One.* To give iridescence to a painting, I use the complement to tone the canvas. Using more complement than color, I place an acrylic wash over my canvas. Only a touch of color is used, so I can use more brilliance in my flowers and not be disturbed by too heavy an underpainting.

◄ *Step Two.* Pure bright color is now placed wherever it is to appear in the finished painting. I add grays to complement the strong bright color. Very little drawing is needed. Instead, value and color are worked out to show the basic shape of each object.

*Step Three.* Grays are now established to work with the colors, mixed according to value and temperature. I use direct brushstrokes throughout the block in stages. Going too quickly to detail can result in an overworked painting, making mud or bad color.

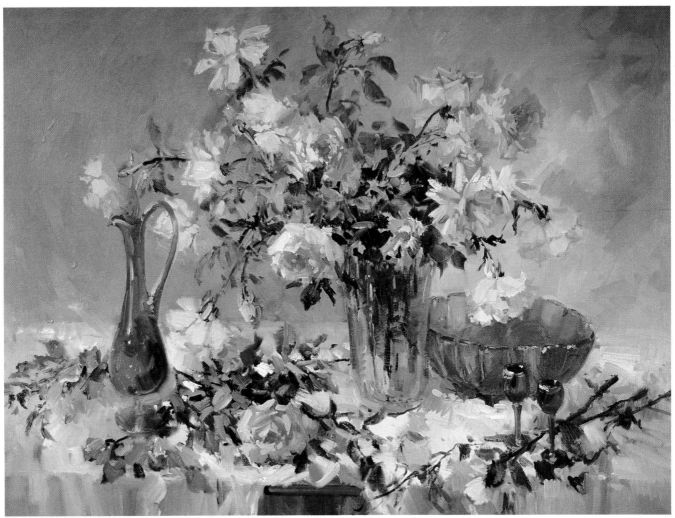

▲ *The Last Roses of Summer, 24 × 36*

Now the fun begins. Each flower and object can now be finished to your own satisfaction. The colors should glow right from the beginning. Each rose now becomes a portrait, and each pot or vase takes on personality as shown in the close-ups on the next two pages.

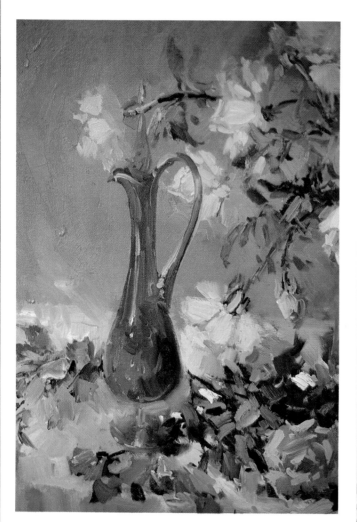

◀ Supporting objects can be
pure brilliant color as long as the
value works.

▲ With so much going on in the
flowers, the vase was played
down, yet it still has personality.

◀ The blue bowl blends with the vase, yet it plays an important role. It is part of the dark pattern tying that area together.

▶ From the detail work in the rose, you can see its relaxed beauty, with color its most important aspect.

# Looking for Originality

*"Your painting will be original if you paint what you want to paint, how you want to paint it."*

Many people lose their confidence when they hear the word "originality." They say, "That's something I don't have much of." But originality is not some magical gift bestowed on a few special individuals; it's as simple as following your own particular interests and tastes. For example, I enjoy painting chairs. I am fascinated by the many shapes and the stories they tell, so I often use a chair as the main subject of a still life. Sometimes I create a whole room setting around a chair or another interesting piece of furniture. Once I found a watering can that interested me, filled it with fresh daisies, and made it a still-life subject. I have even used the core of an apple I had just eaten, along with a few casually placed apples, as my painting subject. I also enjoy using ribbons in many ways in my setups. These simple examples should encourage you to follow your own compass; it will lead you in a direction that no one else has taken.

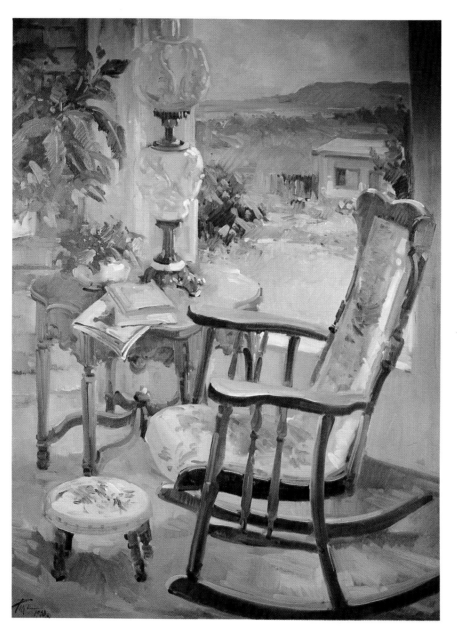

◄ *Grandma's Rocker,*
*40 × 30*

I used a corner of my own living room to do this painting, and the grandma I refer to in the title is me. When I can find a few minutes, I like to sit in this antique rocker and read, looking out the window at the beautiful view of the Morro Bay harbor. The scene tells a story, and it should, because it truly exists and is just as comfortable in reality as it appears to be in the painting. The soft, grayed interior gives more emphasis to the warmer exterior scene. Also, you can see the filtered, cool lights striking the lamp and chair from the window. I have always enjoyed doing paintings that look as if someone just left for a moment. This keeps them in the realm of still life yet makes them seem more alive.

## "PINK ROSES AND SPANISH SHAWL"

I have a model stand in the corner of my studio where I usually arrange room settings. In them I use tables, chairs, interesting drapes, patterned rugs, wall clocks, and so on. I can come up with very convincing room arrangements and still enjoy the convenience of my studio. It also helps to have the setting slightly elevated on the model stand—I like the angle better than when I am looking down on my setup. Wicker has been a favorite subject for a lot of artists. The ornate patterns of the wicker can be fun and appeal to a lot of people. In this painting, the chair is very meticulously or tightly done, while the supporting objects are much looser, allowing the chair to take front and center stage. The soft pink roses break up the very ornate fanback of the chair. The rug has a detailed pattern in reality, yet I painted it in an abstract manner, again to allow the chair to dominate. The beautiful fringe of the draped Spanish shawl makes a dark vertical shape that adds variety to the white wicker.

▲ The photo of the room setting is included to show you how closely I stayed to what I saw in the setup. I played down certain areas such as the pictures on the wall and the ornate rug pattern so they would support the main subject, not dominate it. The wine glass in the painting was added later.

▶ *Pink Roses and Spanish Shawl, 40 × 30*

Chairs and room settings interest me. I often set up a room arrangement in a corner of my studio and paint from it. Find out what it is that interests you, and you will be taking the first step toward originality.

# Rocking Horse

Your creativity and originality can be sparked by simple treasures that fascinate you. When you find something exciting to paint—like this handcarved rocking horse with copper and brass detail overlay—you can have fun thinking of different ways or settings in which to use it.

I have great plans for this little guy; I think he would make a great subject to paint outdoors as well as in the studio. This horse will work in a hundred different setups with my collection of antique dolls and old puppets or with other objects.

▲ *Rocking Horse with Fruit and Lilies, 30 × 40*

Here the beautiful rocking horse is used as a still-life object, as one member of a team of objects—the fruit and flowers are just as important. The horse blends into the busy background drape. The shape of the horse is still very carefully rendered, showing all the decoration and trim; some areas are more subtle than others. The drape, like the horse, is Eastern in origin, and the fruit and flowers were chosen to fit in with this Turkish theme.

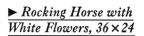
▲ Photograph of the setup.

▶ *Rocking Horse with*
*White Flowers, 36 × 24*

In this painting, the rocking
horse is the star of the show.
Compare the photo of the setup
with the finished painting; you
can see how I simplified the
composition to give the horse its
prominence. After I had care-
fully worked out the structure of
the horse, I added the gorgeous
brass and copper trim, being
cautious not to go too far and be-
come gaudy. The flowers were
completed after the horse was
almost done, because I wanted
the horse to remain the center
of attention. The copper pot in
the foreground repeats the cop-
per trim on the horse and relates
to its Eastern origin.

# The First Steps

*"What appears to be a casual, spontaneous painting is the result of deliberate thought and decision-making."*

A painting should look fresh, not overworked, but strangely enough, it is good planning combined with knowledge and self-assurance that will make this happen. Let's go over the steps I follow to create a painting. First the thought is born, then the setup is arranged. Next comes the toning of the canvas. I use combinations of colorful washes in either acrylic or oil, thinly applied, allowing the pure colors to merge and flow down the canvas in a controlled drip effect, as seen in many examples throughout the book. Next, I draw to secure in my mind where I want objects to be placed. I never do a labored drawing, but draw only as much as I need to work out my perspective and compositional balance. At this point, I am ready to apply the paint. With bold brushstrokes, I block in all the objects using cool shadows and warm lights. Very little detail is needed at this stage. I look only at the large masses or

▶ Photograph of the setup.

▼ *Step One.* First I tint my canvas with an oil and turpentine wash of cadmium red light and sap green, just enough to cover the canvas. I want the canvas slightly wet so my brush will glide easily over the surface. The wet surface also makes it easier to wipe out and make corrections as I do my drawing of this intricate subject.

▲ *Step Two.* Very loosely I apply the correct color and value. Sometimes I use a more intense color at this stage, but here I go directly to the color I will finish with. At this time I balance everything in the painting as loosely as possible, trying not to say too much too quickly.

forms, not at detail. I give dimension to the objects by blocking in the big pattern of light and dark. At this time, all my values and colors are correct, making it easy for me to proceed to any degree of finish that I wish. As you can see throughout the book, I use various degrees of detail, though all of my paintings would be considered impressionistic.

## "WHITE ROSES AND LACE"

The first three steps in still-life painting are to choose, arrange, and light your flowers and objects. Here you see one of my homemade room settings. I wanted the painting to have quite a bit of contrast, so I used a dark background. Remember, I work from the setup, not the photograph; in this photograph the background appears darker than what I actually saw. Before even touching brush to canvas, I decided on a color scheme. I chose to go warm dominant. The warm colors work very well with the delicate, lacy pattern throughout the painting.

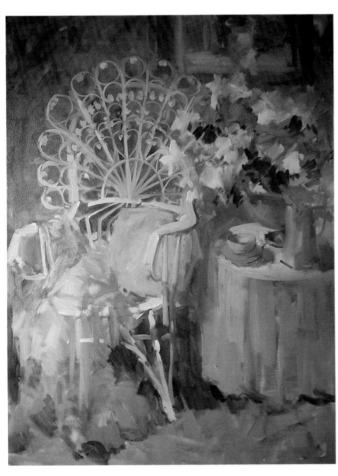

▲ *Step Three.* Keeping detail to a minimum, I secure the shapes of each object. As you can see, I work over the entire canvas evenly—not overworking any one area. My colors don't change from my initial lay-in, but now shadows and lights begin to give shape to the objects.

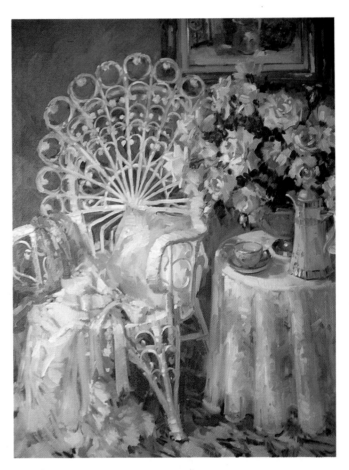

▲ *White Roses and Lace, 40 × 30*

Each object is now brought to completion. The white roses, though somewhat detailed, are slightly grayed, so their detail does not take away from the ornate chair I planned to make the brightest object in the painting.

# *Pulling the Painting Together*

*"Every painting should include a bunch of relatives —
that is, each part must relate to all the other parts."*

Your painting must work as a unit, not look like a random bunch of objects. How do you accomplish this? You need to have a clear idea of what you want to achieve and then learn some specific techniques to help you do it. First of all, you need to think about harmony. Harmony means that if each section plays its part right, the whole will be more than a bunch of nice parts—it will take on a life of its own. Some parts may be loud and forward, while others blend into the background. There is a smooth transition from one part to the next and an overall rhythm that the eye can follow.

There are several techniques that can help you achieve this unity. First, make sure that the background is part of the painting and doesn't look like an afterthought. Keep the background at the same degree of finish as the rest of the painting. It also helps to repeat some of the colors from the subject in the background.

Another way to unify your painting is to overlap some of the objects in your setup. Some should touch, others can have spaces between them—there is no strict rule about this. Keep moving the objects around until it looks right to you. Try squinting to eliminate the details and see the big shapes and color masses. This should help you decide whether your painting balances and works together. Include only important details; don't paint each little petal or leaf.

Losing and finding edges is extremely important in pulling the painting together. If all the objects have hard edges they will look cut out and pasted on—you

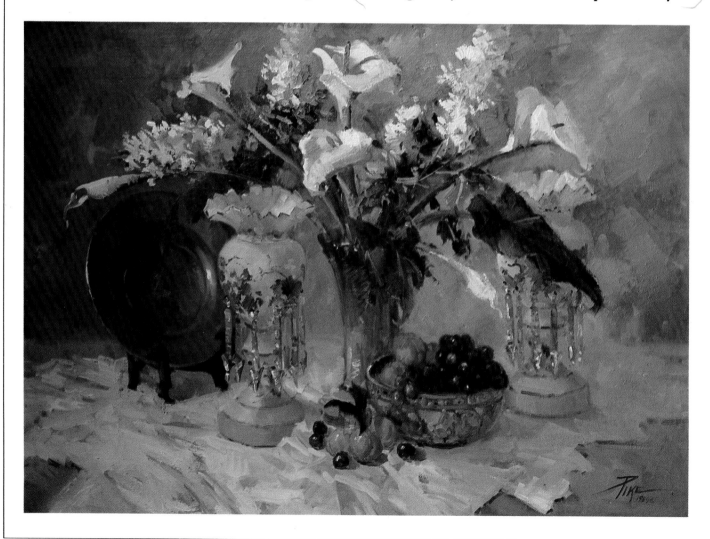

won't have a working unit, just a bunch of pieces. Where and how to vary the edges is the question. I use the simple rule of squinting until I can barely see the setup. Where I see an edge is lost, or at least softened, I lose or soften that same edge on my painting.

## "CALLA LILIES AND LUSTERS"

Here you can see this softening of edges where the brass plate blends with the background at the left of the painting. Distant flowers will merge or soften, giving attention to the ones chosen as the focal point. Notice how the lilies dominate all other objects, even the white lusters. The irregular lace edge on the table helps break up a negative area. Putting everything in its place and making it stay there is of utmost importance in creating a painting.

## "BLUE AND WHITE"

Using a limited palette and similar objects is another way to unify your paintings. Every object in this setup is blue. The complement (orange) was used only to neutralize the blue to a gray. This is a different and exciting way to paint. It allowed me to concentrate on value instead of color. Carefully, I adjusted the darks and lights. I had chosen delicately patterned objects I felt belonged together, such as the antique vase and the blue dish with fruit. I enjoyed painting their detail with limited color. The lacy look of the flowers blends well with the delicate patterns on the porcelain. These two principles—a limited palette and similar objects—used together make a pleasantly unified still life.

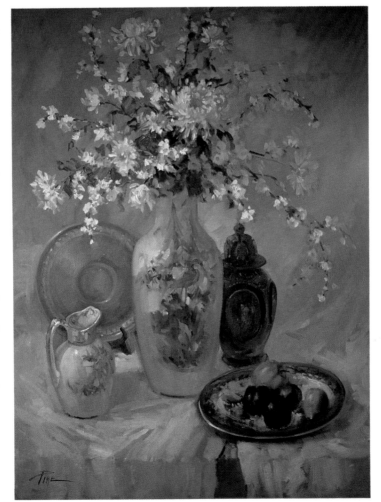

▶ *Blue and White, 40 × 30*

This painting is pulled together by two techniques (in addition to its pleasing composition). First, it is nearly monochromatic. Second, the objects in the still life were chosen for their similarity in style and texture.

◀ *Calla Lilies and Lusters, 30 × 40*

I arranged the objects here to relate to each other according to size, shape and color. I wanted one luster to dominate, while the second luster is barely seen behind the dark calla lily leaf. Flowers are usually the main element in a floral still-life painting. This is true in this setup; the regal beauty of the calla lily commands attention. I used a darker background to show off the stately flowers.

# *White and Silver*

Another way to unify your painting is to choose a theme. The title of this painting is also my theme: *White and Silver*. The objects were arranged according to value more than color. I chose to have very little color in this painting, making it a study in beautiful glowing grays. I used my silver coffeepot, which takes on the colors around it. The white objects were chosen to work with the soft flowers: white foxgloves, lilies and mums—

a nice medley. The cup and saucer recall the coffeepot. I often place flowers on the table to fill negative space, or sometimes to give a soft touch to the painting. The small silver candy dish continued the use of silver in the painting. The dark, graceful leaves of the calla lily contrasted with the white flowers. I am now inspired and ready to begin the painting.

▶ Photograph of the setup.

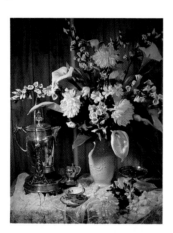

◀ *Step One—Toning Your Canvas.* More color is used for the initial wash than will be seen in the finished painting. I do, however, use each hue where I want to see it with more intensity in the finished painting. You can see from Step Three that I don't change the initial wash as I establish the grays.

▲ *Step Two—Drawing.* Using only a small amount of thinned ultramarine blue, I carefully secure the placement of each object in the painting. I make sure my drawing is correct and plan the composition. Again, I don't lay on paint too quickly. I must be sure of the placement of each object before building a composition around it.

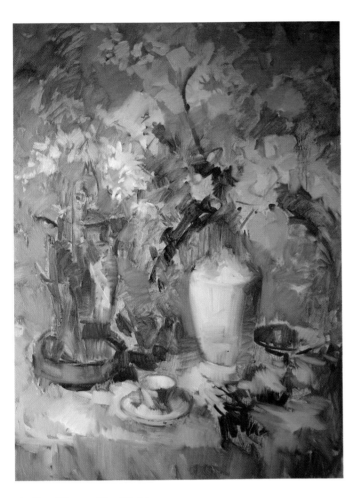

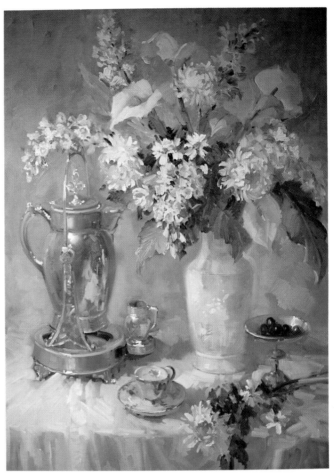

▲ *White and Silver, 40 × 30*

As I finish each object, I keep squinting at my setup. Squinting helps me see the whole picture and keeps me from overstating any one object. Carefully, I secure the focal point where the white flowers come closest to the viewer. Then I start establishing the subtle colors I see in the silver objects, the white porcelain cup and saucer and the vase. You can see how important it is to control or soften edges. This is one of my favorite paintings because of its beautiful grays.

▲ *Step Three—Establishing Values.* I establish subtle colors and grays to build my composition, working over the entire canvas and trying not to finish one object before all of the values are established. This will give me a better idea of how far I want to finish it. What I see at this stage should be what I want to see at the finish, only a bit more abstract.

# Lighting the Still Life

## "The cast shadow is part of your composition."

Lighting is one of the most important parts of your painting. Never try to imagine the source of light. Use one good direct spotlight or the light from a window. If you use a spotlight, you have a choice of temperatures. Cool light bulbs can be purchased from your art supply store. Most spotlights are considered warm and can be purchased anywhere. If you decide to use natural light from a window, your light source will be cool and your shadows will appear warm. In my studio, I use a 100-watt warm spotlight. I don't want extremely strong contrast. If you like stronger light, try using a higher wattage bulb. A good light stand enables me to raise or lower the spot to control cast shadows, which are a major part of my painting. If you plan to use light from a window, you must take the shadows as they fall. This is still an exciting way to work. Filtered light (sunlight is always filtered through the air) will create less contrast. Most artists prefer filtered light. To a painter with some experience, it can be exciting and stimulating.

### "PETUNIA SHADOWS"

My subject was a large antique porcelain wash basin filled with floppy white petunias, with a few lavender ones added for color. By raising and lowering the light on my light stand, I could adjust the shadow pattern to make the statement I wanted. What fascinated me was the way the folds of the cloth go from shadow to light. I carefully drew in my objects, allowing enough room for the tablecloth, so I could use this interesting cast shadow pattern in my painting.

▲ **Petunia Shadows, 24 × 30**

I wanted to keep the shadows in a cool blue-violet range to draw attention there. The flowers were still the focal point, but these beautiful cast shadows were worth a second look. Areas like these help raise the painting above the usual floral still life.

### ▶ *The Blue Bowl, 14 × 18*

This blue bowl jumped out at me as I placed it against the soft gray background. Its starkness was overwhelming. By raising the spotlight, I was able to cast a dark shadow on the light tablecloth and surround the blue bowl with darks. The dutch iris and white daisies were then easy to arrange into a pleasing still life.

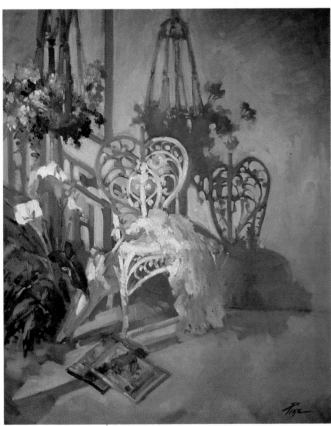

### ▲ *Shadows on the Wall, 30 × 24*

The early morning light had cast a beautiful shadow on the back wall of my house. The macramé always hangs there, but this time I noticed how interesting its shadow was. Putting a chair by the hanging plant, I created a pattern of lacy shapes in the shadows. By keeping all colors subtle, I brought these strong shadow patterns to a high degree of finish without overwhelming the rest of the painting.

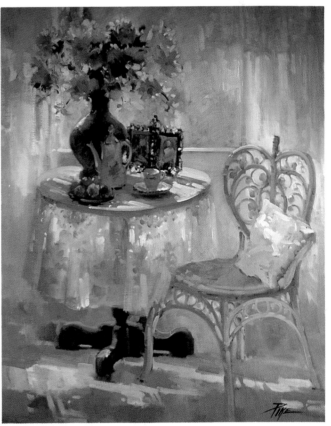

### ▲ *My Studio Window, 30 × 24*

One end of my studio is set up as a room where a window is the light source. If I face the window, my setup is backlighted. Backlighting creates silhouettes and subtle shapes. The lights are cool, the shadows warm. Here the flowers were rimmed with a cool halo. The foreground lace appeared dark, while the lace visible through the cloth was bright white. Trying different lighting situations stretches your artistic skills.

# DEMONSTRATION
## *Apples and Oranges*

In this section I have shown you several examples of unusual lighting. Now I want to show a very common lighting situation. I arranged my setup using a midvalue background to make the white matilija poppies pop out. I had also decided to make yellow-orange my dominant hue. It is easy to tell where the light is coming from; the light falling on the objects and casting shadows comes from above and slightly to the left of the arrangement. Lighting from this direction or the opposite—from above and to the right—is probably the most common used in studio painting. Such lighting defines the objects while not drawing too much attention to the light source itself.

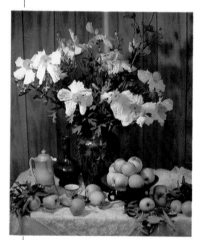

◀ Photograph of the setup.

▼ *Step One—Toning and Drawing.* Very little of the complement is used throughout this painting, just a small amount in the grays. I gray my yellow-orange with blue-violet, staying a bit stronger in yellow-orange where the fruit will be placed. Then I draw in all of the objects to make sure they will fit correctly on the canvas. I let the orange leaves drape over the table edge, casting an interesting shadow.

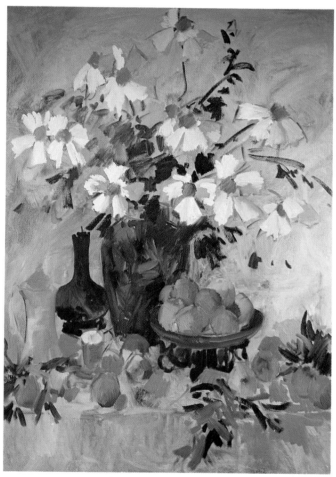

▲ *Step Two—Blocking In.* My painting will be more dark than light, calling attention to the beautiful matilija poppies. I paint all light areas—the flowers and tablecloth—first. Then I build up the color in the fruit before I place in the background. When painting a flower like the matilija poppy, you should show the specific shape from the beginning, making it more recognizable.

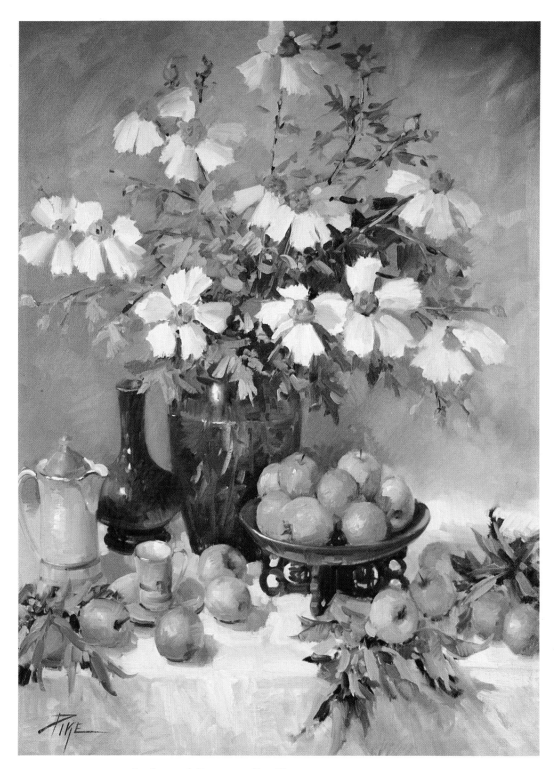

### ▲ *Apples and Oranges, 40 × 30*

After I've secured all the colors and values, the finishing is all that is left to do. I don't want to go too far, so I carefully start with the colorful pattern of fruit and work out from there. I choose a few oranges in the dish for the strongest lights, playing down some of the fruit on the table. The leaf patterns on the table are grayed greens so they don't stand out and take away from the fruit. The direct brushstroke on the tablecloth helps to keep the painting from looking overworked. The cast shadow on the vertical angle of the table adds interest, yet is neutral enough to force the eye back to the focal area.

# Dramatic Lights and Darks

### *"Plan your darks well in order to paint your lights."*

A good painting usually contains a full range of lights and darks—using only middle values makes for a dull painting. That does not mean you should have an equal amount of light and dark. A good way to compose a painting is to make it predominantly dark or light. I sometimes think of a dark painting as being more dramatic. In a dark painting, the lights stand out and command attention. A light painting can be just as exciting, yet it tends to look softer. If there is a question on balancing the values in your painting, use the two-thirds theory: Make it either two-thirds light or two-thirds dark. The remaining third is the positive area where most of the statement is made through contrast. When

I refer to darks or lights, I don't mean just black and white but all the subtle value changes that take place within the larger mass of dark or light. When a painting is near completion, you can add tiny points of highlight on the light-struck objects. This lends reality to your painting and adds sparkle and excitement.

### DRAMATIC DARKS: "CARNATIONS AND BRASS"

When planning a dark painting where you will be using a dark background, try to select backdrops with some color. I used a dark red velvet drape for this setup that gave me the dark value I wanted and also a bit of dominant color. The red and pink carnations cover only a small amount of my canvas, but they stand out mainly

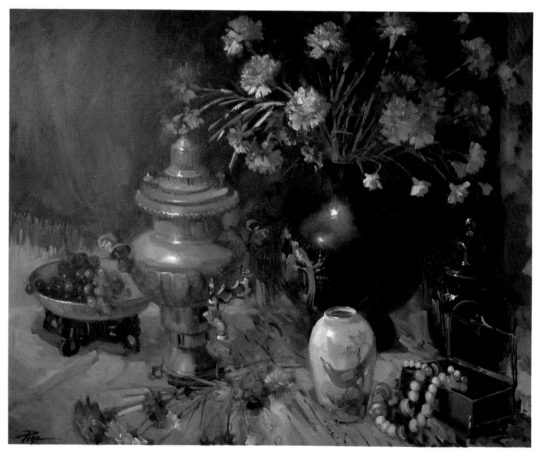

### ▲ *Carnations and Brass, 30 × 40*

When you do a dark painting, select rich, colorful objects. Small bright highlights can be added to these objects at the end of the painting for sparkle.

because of the darks around them. The small vase and beads near the bottom of the canvas bring the eye down from the flowers and back up again, completing the trip through the painting. I used several dark objects in this painting that were brought into view with only the smallest highlight striking them. The folds of the cloth and the few scattered flowers fill the negative space and add needed color.

## DRAMATIC LIGHTS: "ORIENTAL BLUE"

This painting was set up almost entirely with white or near-white objects. A bit of blue decoration is seen on two of the bowls and, of course, the large vase. I put a dark blue ginger jar in the background to break up all the lights I used. The background itself was actually white. Because of the light striking the flowers, the background appeared to be darker, giving strong contrast where it was needed in the flowers. Painting white on white means only that you are doing a light painting. To show objects correctly, you will still have to incorporate many value changes, but the final painting will be more light than dark.

◄ *Oriental Blue, 40 × 30*

When doing a white painting, make your whites as colorful as you can and still make them appear white. To do this you must carefully study the value relationships.

## SECTION THREE

# *The Shapes of Flowers*

It can be frustrating to look at the complexity of a flower. You want to duplicate its beauty, but you don't know where to start. All intricate objects such as flowers have a simple underlying structure. The trick is to find that structure so you can create a convincing replica with a minimum of strokes. This may sound easy, but it can be hard to simplify what we see. In the following examples I have tried to show you how I simplify the form of some popular kinds of flowers. Examine each step carefully and do some practice exercises yourself, setting up simple subjects as in the examples. We never outgrow the need for practice. Even the greatest of the greats must do preliminary sketches or detail studies like those in this segment. Practice time is time well spent. In setting up a practice subject, don't make it complicated. The purpose is just to familiarize yourself with the different angles and shapes of the flowers and their personalities.

# *Daisies*

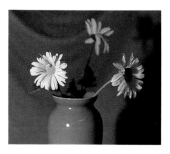

◄ The daisy is shaped like a wheel with a slight indentation in the center. Its petals can separate or flop in one direction or another. The center is like a yellow button, changing color and value as it turns toward the light. See how the wheel shape changes from light to dark.

▶ *Step One.* On a toned canvas I draw an ellipse to suggest the shape of each daisy and its direction. I cut out asymmetrical pie-shaped wedges—irregularity is more interesting—and indicate a center, but not necessarily in the middle of the ellipse.

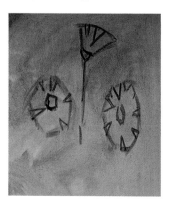

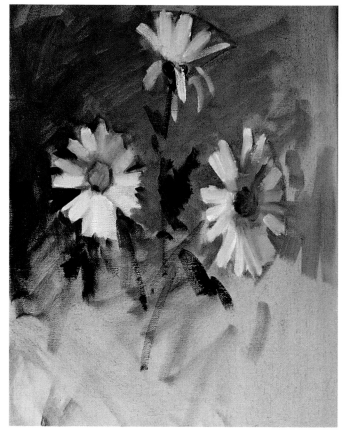

◄ *Step Two.* With a minimum of strokes I scrub in the dark background, further defining the wedges in the daisy. Next I wipe out paint where the lights will be placed with a clean cloth or tissue to help keep the colors clean. The light area is painted with white and a touch of cadmium orange, just enough to add a glow to the white. The shadows are painted with ultramarine blue, cadmium orange and white; I adjust the mixture as the flower turns from light to shade.

▲ *Step Three.* In the final step, I look for areas such as the relaxed petals on the daisy in profile, or the curved petals on the daisy to the right. These personality traits need only a minimum of strokes. Petals should be painted from the tip first. If this stroke were reversed, the edge of the petal would appear to be irregular. Centers are placed in using a grayed green for the shadow and yellow-orange for the light areas.

# *Chrysanthemums*

▼ I arranged a few blooming chrysanthemums—one facing up, one down, and one seen from the back—and a bud. Chrysanthemums are linear flowers, that is, they are irregularly shaped with the linear petals sticking out every which way. To express that quality I use a simple stroke of my brush for each petal.

▲ *Step One.* I tone the background with a warm gray wash of sap green and cadmium red light. Using a wipe-out cloth, I place in the flowers. I show the direction of each flower by indicating the center or the calyx with a bit of background color.

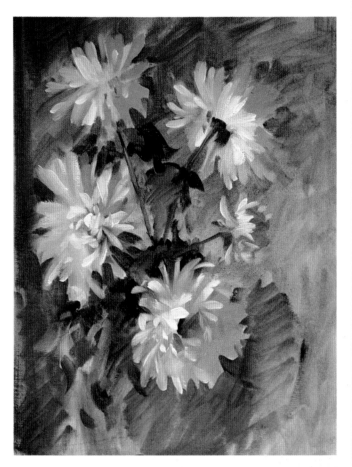

◀ *Step Two.* I add the shadow areas of each flower with a mixture of ultramarine blue and cadmium red light plus white and use an irregular edge to just indicate the petals. I vary the shadow hue slightly on each flower to keep them from all looking the same. Then I suggest the leaf pattern using a mixture of sap green and cadmium red light.

▲ *Step Three.* Next I paint the light petals selectively. I only paint about one-third of what I think I see, being careful not to go too light when placing lights within the shadow area. The light petals close around the dark centers giving the unique shape to the chrysanthemum. Before I paint each petal, I think: Is it really necessary? The finished flower shouldn't look like a bunch of worms.

# *Stalks*

▶ Learning to paint single blossoms is fun, but a very important part of a floral painting is the supporting mass of flowers used to fill negative spaces. I have selected several examples to show how the many value changes are used to create the shape of the flower. To show volume, there will be strong light on only a few. Remember that darks are always more important than lights when painting white flowers.

◀ *Step One.* Using black, ultramarine blue, and a touch of cadmium red light, I tone my canvas with a color-controlled gray. Color controlled means that I intend to use several blues and some warmer tones, not just black, on my finished canvas. After I apply the wash, I wipe out each blossom separately, though I intend to complete them as one mass of blossoms.

▲ *Step Two.* Now the shadow side of each flower is placed in. I use several grays, some warmed with a touch more orange, some cooled with more blue. All values are controlled with white.

▲ *Step Three.* To show volume, I build three separate piles of paint of different values. One is white with a tiny touch of cadmium orange; one is white with a bit of shadow tone added. The third, cadmium yellow and white, is for my whitest area. As the flowers recede, I diminish the value. A hint of a bud and a few yellow-green stems are seen at each tip.

# Carnations

▲ Carnations come in a variety of sizes, from tiny ones called "pinks" to larger, more exotic shapes. They consist of many petals that look as if they have been jammed together to form a tight but beautiful ball. The leaves and stems are straight, with very little bend to them, and their color is usually a soft gray-green. When doing a practice subject, let the flowers in the vase go in several directions to show the interesting calyx, shaped like an ice-cream cone on a stick.

◀ *Step One.* I tone in the background with a warm wash of cadmium red light and sap green. Pure Grumbacher Red is used to place every flower—red and pink alike. Shadow areas are added with pure alizarin crimson. Red and pink flowers are treated alike at this stage.

◀ *Step Two.* Here I wipe out some of the red pigment from the pink carnations. I leave enough color to keep the shadows strong. It is better to go a bit darker in shadow than what you think you see; your lights will appear stronger with more contrast. It is easy to soften or lighten shadows later if needed. The carnation leaf is very slim and light gray-green. I suggest only a few to show their color and personality. More important are the cone-shaped calyxes of the flower in profile.

◀ *Step Three.* Once my darks are secured, I am ready to paint the lights of the pink carnations with Weber Floral Pink plus white. Starting from the outer edge and using a loaded brush, I place in the light petals, varying the color and value where appropriate. The finished flower has no visible center, just layers of petals. For the red carnations I use cadmium red light for the few petals that catch the light. No white is added to the red carnations.

# Dogwood Blossoms

► The dogwood is native to the South, where it grows prolifically. Dogwood blossoms come in two colors—white and pink. They have a simple shape with only four petals. A distinctive dark mark makes it look as if someone has burned a tiny hole at the tip of each petal. The centers are usually yellow-green. The petals curve and turn as the blossom is viewed from different directions. The single flower is lovely, but the blossoms are even more beautiful in a cluster. In this study, I will show you the basic shape and also how to mass the blossoms together.

◄ *Step One.* I tone the canvas with a wash of sap green and cadmium red light. At this point no strong color should be used. With Grumbacher Red, I suggest several blossoms, principally the ones I will be bringing to completion. These are the ones that best show the shape of the dogwood flower.

◄ *Step Two.* Very loosely I bring in a few darks with some well-chosen brushstrokes, achieving both value and color balance without a heavy buildup of paint. I can work over this thin application without messing up the flowers.

► *Step Three.* Each flower is now finished to the degree I feel is necessary. I don't want them all to be of the same color or importance, so I carefully choose the ones that will draw the eye first. Students frequently paint all flowers or petals alike. Be careful not to get into this bad habit.

► *Step Four.* I further carve out the shape of the flower by bringing the background up to meet the blossom. I am very careful to use my strongest value contrast where I want the focal point to be, controlling the values and softening some of the outer edges. This is the most important step in showing the nature of the dogwood blossom.

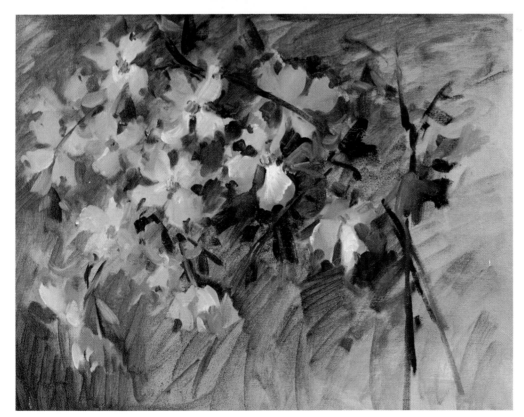

◄ *Step Five.* Now I look at the details. The dogwood blossom has four petals, each with a small cutout area at the tip that resembles a burned spot. The centers are yellow-green. Because the dogwood is a tree, I include a few branches to show how they grow. It is easy to get carried away with things such as twigs, branches and leaves. Be careful. Let the blossoms dominate your painting.

# Gladiolus

◄ The gladiolus is a long-stemmed flower that can be used alone or with other flowers in beautiful arrangements. I set one up facing straight on and a second in profile to show the full character of the flower. These particular gladiolus are silk, but when available, the real thing can't be beat. In profile, the flower extends out a short way from the main stem. As the buds open, they all lean to one side of the main stem. This unique feature helps to separate the gladiolus flower from others that are similar.

◄ *Step One.* The canvas that I am using for the gladiolus study is an old painting that I had covered with a thin white wash. These flower studies can make good use of old unsuccessful paintings. First I block in the long, graceful stem and suggest the placement of the leaves. With the same dark green, I show how the flowers separate and lean away from the stem on the profile flower. Using only Indian yellow for the yellow flower, I block in the outside shape. For the pink flower, I use Grumbacher Red and a bit of Indian yellow. At this point I concentrate only on the simplest shape of the whole flower—no details.

◄ *Step Two.* In the initial sketch, the flowers read dark against light, but in the finished painting, they will be reversed, light flowers against a dark background. At this point, I place in the darker background values. The leaves are beginning to read as light against dark and should only be suggested at this stage. I need the dark background to contrast with my last step, which will be to model the petals with lights.

◄ *Step Three.* After blocking in, I am ready to add the detail. First I place in the centers using alizarin crimson and ultramarine blue, being careful to place them as I see them. The flowers must overlap slightly, and the position of the center will show that feature as well as which direction the flower is facing. Now I place soft shadows only where there really are shadows. The mixture for the shadows is ultramarine blue and Grumbacher Red plus white for the pink gladiolus; cerulean blue and cobalt violet plus white for the yellow gladiolus. Next, I paint the highlights. These mixtures must be clean and applied with a clean brush.

# *Matilija Poppies*

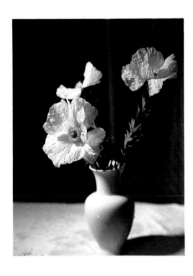

◄ All poppies have basically the same construction and differ only in the vivid variety of their colors. My first love is the wild matilija poppy. Its exotic bloom is native to my home here in Morro Bay. Their petals look like crepe paper, yet the flower is as delicate as a butterfly's wings. I find that two values are usually enough to capture the likeness of these petals. The center is a fuzzy ball, orange and yellow with a touch of deep red in the center. The leaves are grayed green and straight, with seven or more points extending from the main body of the leaf. When painting this delicate flower, I go darker in the background. Subtle value changes are easier to see with strong contrast.

◄ *Step One.* I tone my canvas with a middle to dark tone using alizarin crimson and sap green. I sketch in the basic shapes with ultramarine blue and turpentine, suggest the shapes of the poppies, then wipe out the areas where the lights will go. Shadows are indicated with a neutral gray. I use a direct painting stroke that can remain on the finished study.

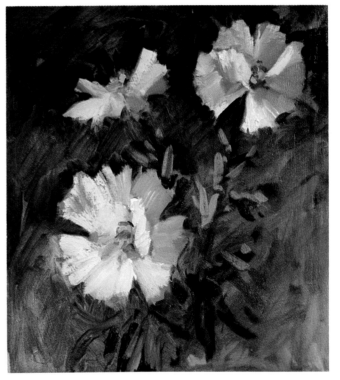

▲ *Step Three.* I use the background tone to complete the personality of the matilija poppy, sculpting around the edges where necessary. A few pie-shaped wedges added wherever possible break up the rounded look. I place leaves first in darker grayed green, using cadmium red light and, predominantly, sap green. Then I bring out some of the leaves by adding thalo yellow-green and white to this same mixture.

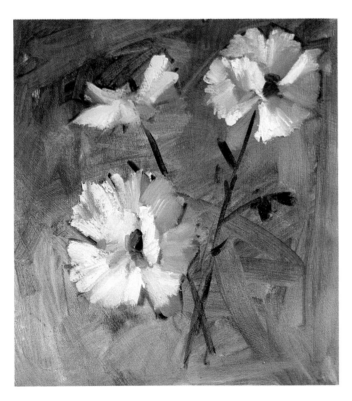

▲ *Step Two.* Using the same well-directed brushstroke, I place in the lights using white with a tiny touch of cadmium red light, just enough to liven the dead look of the pure white.

# Calla Lilies

▶ The regal beauty of the calla lily adds much to a bouquet. Even the beautiful yellow-orange stamen in the center of the flower is statuesque. The deep green leaves are large and solid, their edges sometimes appearing scalloped. They make a great dark contrast to the flower. When setting up the calla lily, move your light around and choose a direction that creates obvious shadows and lights. Stronger contrast makes for a more convincing flower shape.

▶ *Step One.* After applying a thin wash of warm gray (sap green and cadmium red light), I wipe out the area where the flower will go with a clean cloth. Then I sketch each flower carefully to show the exact shape. The calla lily is a stiff flower and should be painted as a portrait, not as a generalization.

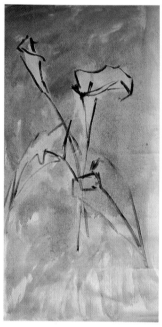

▶ *Step Two.* With a minimum of strokes, I place in shadows and lights as I carefully observe them. The same mixtures are used for the calla lily as for the matilija poppy. At this time, I also place in the patterned darks of the stems and leaves. Painting the leaf darks first makes it easier to get the correct value and color for the light-struck leaves.

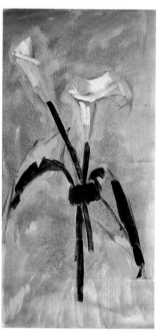

▶ *Step Three.* Once I have created my shadow and light pattern on a flower, I seldom go back to repaint that area. I find that the fewer strokes I use, the better the finished look. I add light to the leaf pattern and structure to the leaf by showing one from the front and the second in profile. Details such as the center vein of the leaf and the stamen are added. Only one stamen is seen in this study. I use sap green and cadmium orange for the first step. Then, with a touch of cadmium yellow light and cadmium orange, I finish the light striking the stamen.

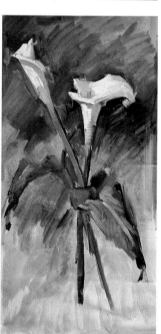

# Lilacs

◄ Lilac bushes vary in size from small to very large. Lilacs are a massing flower made up of many tiny florets. Their outer edge is irregular, but as a whole they are structured much like a small stick of cotton candy. They extend in several directions from their supporting stem. Some stand straight up while others bend or droop. Because the lilac blossom has a solid shape, it must be painted with five values to show such as dark darks, midtones, lights, highlights and reflective light.

◄ *Step One.* Using a wash of cobalt violet and sap green, I tone the canvas. I wipe out areas where the flowers will be placed. With mass flowers such as lilacs, I build the shape of the flower using masses of dark, light and midtones. I use cobalt violet and alizarin crimson to secure my strong darks. Then I add a touch of cerulean blue and white for the lighter lilacs seen to the right in our study. Some of the strong darks to the left will remain, showing the darks deep into the mass of florets.

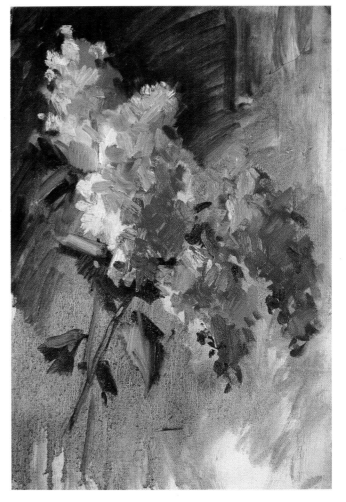

▲ *Step Two.* Using Weber's Floral Pink and a touch of cobalt violet plus white, I start building the shapes by placing in my lightest lights. This makes it easier to see the value or hue changes needed to build the entire mass. Each brushstroke is direct and unblended, giving a more realistic look to the flower. A bit of cerulean blue and white is seen in reflected lights.

▲ *Step Three.* A few tiny florets are seen at the tip of each mass. They are unopened buds and are darker than the mass. As in the other flower studies, I darken areas to show the contour of some of the flowers. The leaves are rounded in shape.

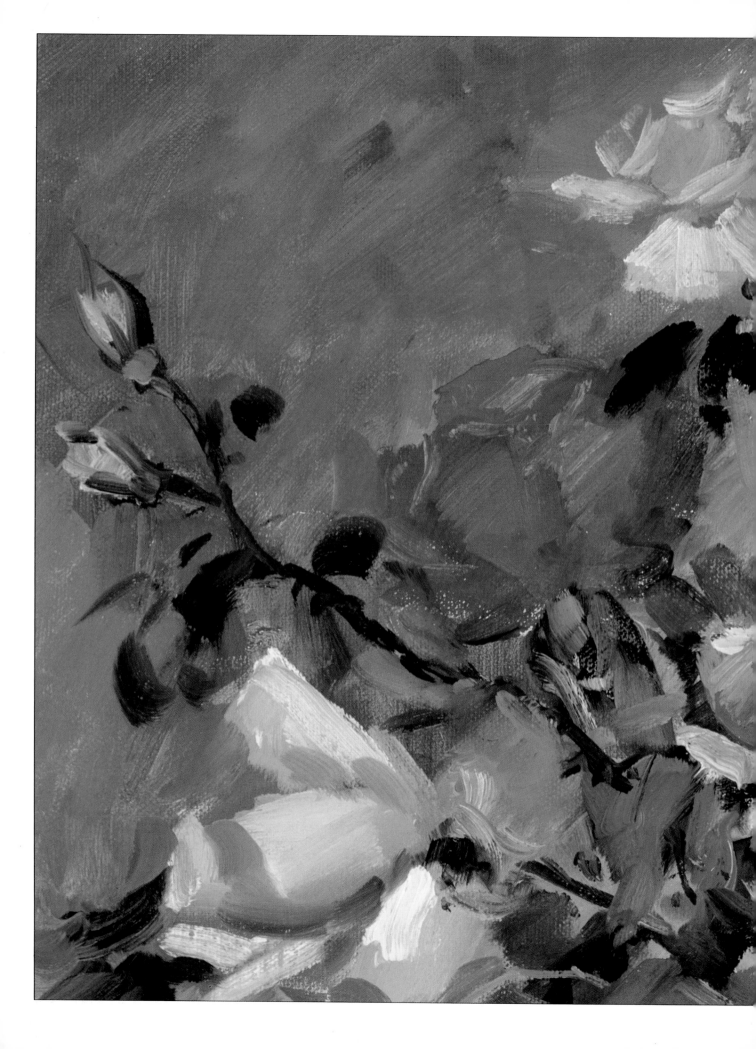

## SECTION FOUR
# *Painting Roses*

The rose is one of the most beautiful, enchanting, romantic and nostalgic of all God's floral creations. Many years ago, I vowed to work on the structure of the rose and study every variety until I felt satisfied with the outcome. It took most of a year of hard work. My goal was to paint the personality of each rose both in complete detail and impressionistically, using limited brushstrokes. Yet, with either technique, I wanted the live rose to show through. That year was one of the best investments I have made as a painter. Still, as well as I know the rose, it never fails to charm and fascinate me.

# The Perfect Rose

*"The perfect rose is just an ideal. You have to make it come alive."*

During my year of study, I found the best way to examine the rose was to carefully dissect each petal until I understood the entire anatomy. As I selected roses to do a study, I limited myself to no more than three at a time. Then I studied the temperature of the shadows and lights, determining where the most color is seen — usually at the center of the rose. Reflected lights are also necessary to show a lifelike rose. Shadows are alive, yet grayed, with the light areas showing true color and structure. All of these elements are necessary to build a perfect rose. But remember, *you* define perfection in your work, not someone else.

▲ *Step One.* I divided a 16″ × 20″ canvas into four equal parts. Using a single rose as a model — working from memory won't do for this exercise — my first step was to look only at the contour of the rose. For my study, I painted all four contours exactly alike using alizarin crimson only. I then went on to a greater degree of finish in each sequential block so you could compare them side by side.

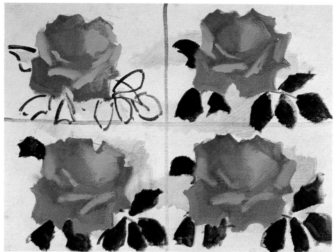

◀ *Step Two.* I wipe out where light petals would be placed using a rag or tissue wrapped around my forefinger. Next I place in only light-struck petals using Grumbacher Red plus white.

◀ *Step Three.* I place in reflected light using cerulean blue, alizarin crimson, and a small amount of white, only in the third and fourth boxes. Leaves and background are placed in using alizarin crimson and sap green. The very final touches are added to the last block: adding the center; enhancing the lights on the lightstruck petals and leaves; softening edges; possibly losing an edge if necessary.

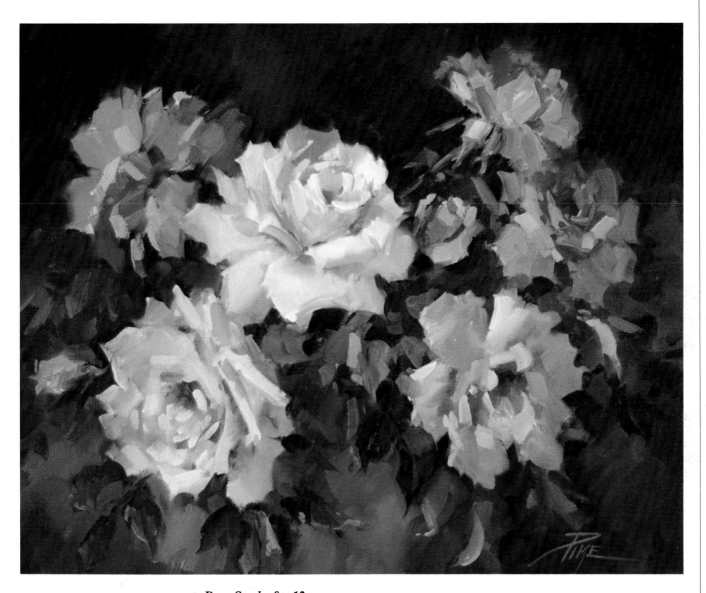

### ▲ *Rose Study, 9 × 12*

For this study I selected several roses seen facing in different directions. Some face up, some down; one is seen from the back, one in profile. Two buds are in different degrees of opening. The white roses were chosen to give stronger contrast with the very dark background. Notice how the white rose turned slightly downward is grayed compared to the ones selected to show focal point. All the pink-toned roses support the white in value yet give a pink dominance to the painting. Leaves are only suggested. They were not meant to divert attention from the flowers, yet they were necessary to complete the study as all roses are seen with leaves.

# *Yellow Roses*

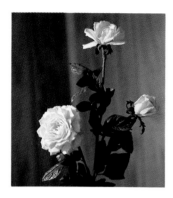

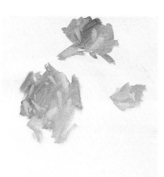

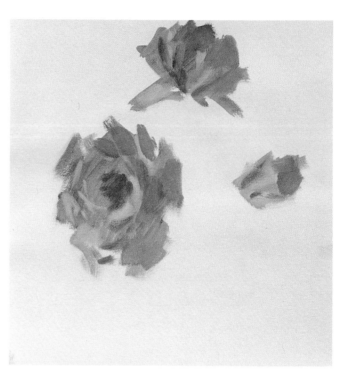

▲ These are three very good silk roses. You can use artificial roses, but get as good a rose as you can. It's also a good idea to use a few real rose leaves. This will help you paint with more realism.

▲ *Step One.* Using Indian yellow, I first placed in the contour of each rose and bud.

▶ *Step Two.* I placed in shadow areas using cadmium orange, ultramarine blue plus white. Centers are sap green plus cadmium red light.

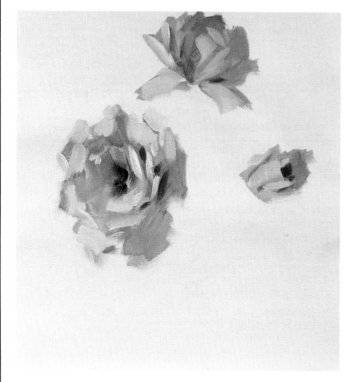

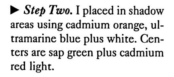

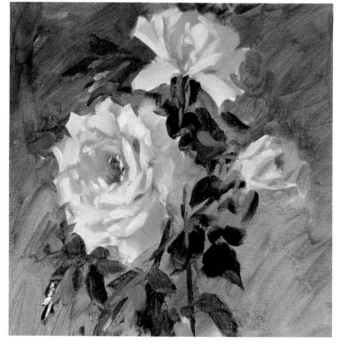

▲ *Step Three.* I wiped out where lights will be placed. Then I strengthened a few darks seen between petals, again using the sap green/cadmium red light mixture that I used for the centers.

▲ *Yellow Rose Study, 12 × 9*

Although this is just a study, you can pay attention to details like the background. Be selective with color. The warm color of the background here works well with the pale yellow roses. The highlights on the rose are cadmium yellow light plus white. They should be added very selectively.

### ▲ *Yellow Roses with Dark Background, 30 × 24*

By placing the large bouquet of yellow roses in a copper vase and
carrying out the dark copper tones in the background, I kept the
flowers separated. The blue platter adds a touch of complement.
The fruit helped to keep the painting in a warm hue. Cast shadows
lessened the amount of light on the table, and the books also cut
down light to keep the painting mostly dark.

# Open Pink Roses

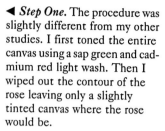

**◄ Step One.** The procedure was slightly different from my other studies. I first toned the entire canvas using a sap green and cadmium red light wash. Then I wiped out the contour of the rose leaving only a slightly tinted canvas where the rose would be.

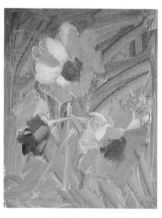

**► Step Two.** I placed in darker centers with Grumbacher Red. I then added white and a touch of cerulean blue to the Grumbacher Red, making a soft pink/gray shadow area. The bud is stronger in color so I used more Grumbacher Red.

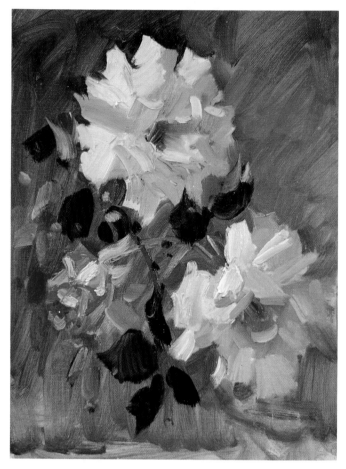

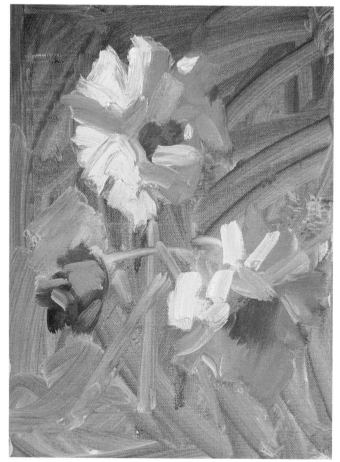

**◄ Step Three.** The light brushstrokes are carefully but directly applied without blending. When you blend, you often lose things that should be retained.

**▲ Open Pink Rose Study, 12 × 9**

I carefully carved out the rose by placing the dark of the background directly around each petal. The leaves support the composition. The shape of the bud is painted exactly as I saw it. As no two buds or two roses are exactly alike, it is absolutely vital to study the rose before you start to paint it.

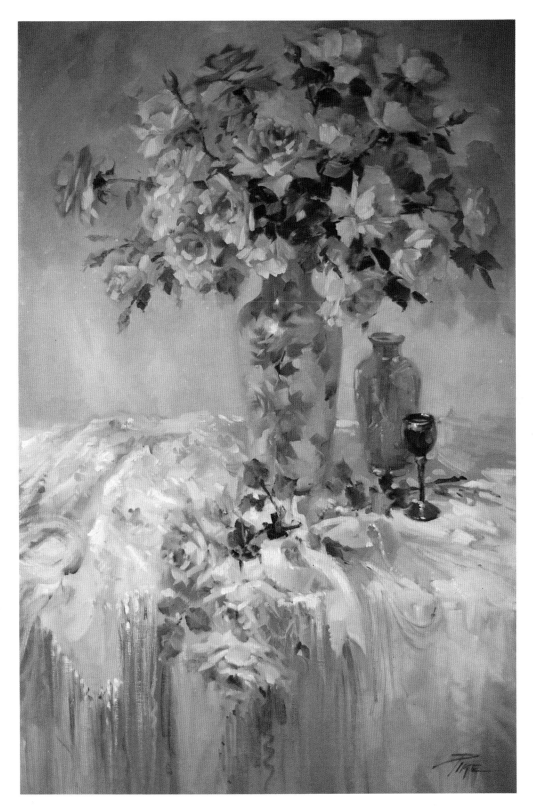

### ▲ *Just Pink Roses, 36 × 24*

I had a bumper crop of Queen Elizabeth roses early last spring. I
arranged some in a tall porcelain vase I had painted myself. The
Spanish shawl is covered with hand-embroidered pink roses. I had
a beautiful setup of soft pink complemented by the blue shawl.
Adding a little orange to several of the roses, I kept my color scheme
working well. The beautiful shawl cascading down the table with
roses bent down in the same direction completes the composition.

# *Bell of Portugal*

▶ This beautiful rose is a climber, so it lacks long, strong stems. Most of the blossoms hang down, resembling a beautiful soft pink bell. I used several old paint brushes to hold some of the roses up so I could see them. I grouped several together because that is how they grow on the bush.

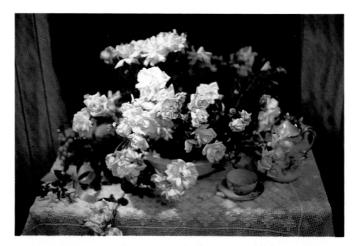

▶ *Step One.* After toning my canvas, I add white right from the start, because the painting is made up of so many grays. I also establish the darks for the background. Only a thin tint is necessary to indicate my intentions. The painting will go toward violet-pink, giving a soft glow to the delicate objects.

◀ *Step Two.* I refine the roses by making only a few come front and center and hinting at the shape of those lost in the background. Each brushstroke is deliberate, with little or no blending. As I paint the light on the roses, I warm my pinks by adding Grumbacher Red to the white. I also place in the darks around the roses, building a pattern of light and dark.

▼ ► These closeups reveal how little is needed to show what appears to be fine detail. Notice how few brushstrokes are in the leaves.

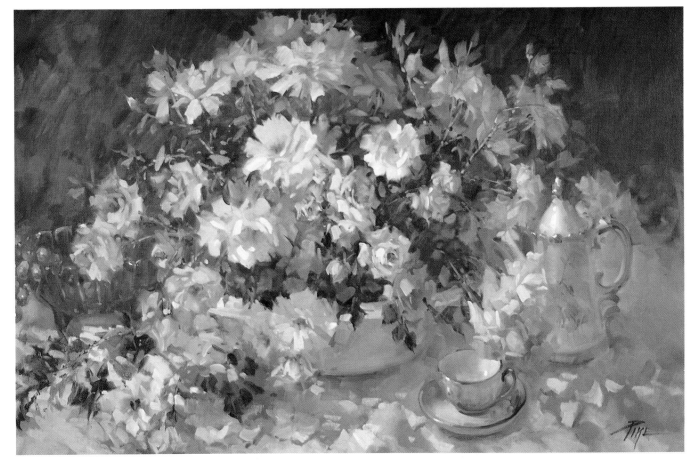

▲ *Bell of Portugal Roses, 24 × 36*

After finishing each object I add a bit of sparkle with a few well-chosen brushstrokes of intense color in the background. I also finish some of the fallen petals and add touches to the lace tablecloth. These finished brushstrokes add animation for a lively painting.

# White Roses

▶ *Step One.* To tone my canvas, I place a small amount of cadmium red light acrylic at the left side of my canvas, Acra Violet acrylic at the right side, and a bit of sap green near the center. Using a spritzer and brush, I softly merge the hues to cover the canvas. After my canvas is completely dry, I can place in my sketch, working out the placement and perspective of each object.

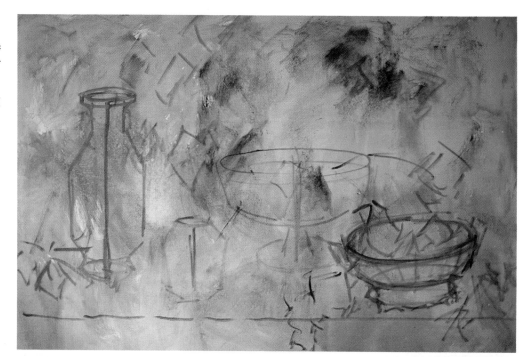

▶ *Step Two.* I place each rose using a bit of Indian yellow on the light-struck side and sap green and Indian yellow in the shadows. My darks are sap green, ultramarine blue, and a touch of cadmium red light. The painting will be cool with touches of warm on the light-struck side of the vase and in the dish of fruit. Once my values and color temperature are worked out, I am ready to start refining the objects. Starting with the flowers and using more detail, I work out my focal area. This is the best way to proceed, because now I have something to relate everything else to.

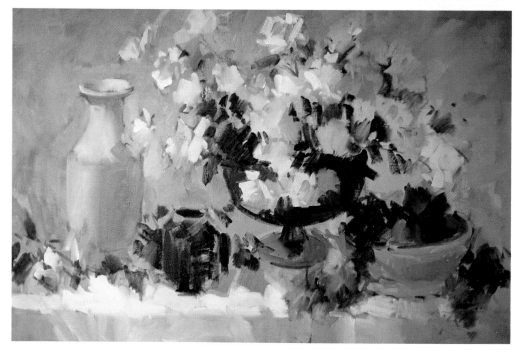

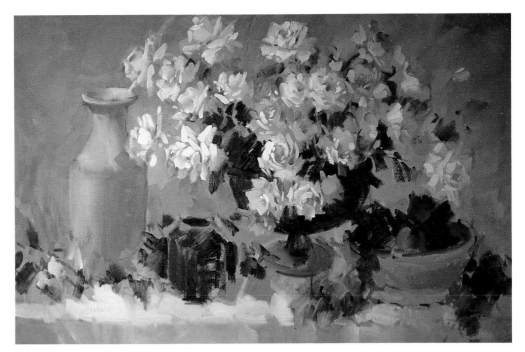

▶ *Step Three.* The roses are painted as a group; only a few are brought into detail. Some seem almost lost as they merge into the soft grayed background. By warming the white vase, I separate it from the mass. To bring more attention to the blue ginger jar, I play down the bowl of fruit by placing it on the shadow side.

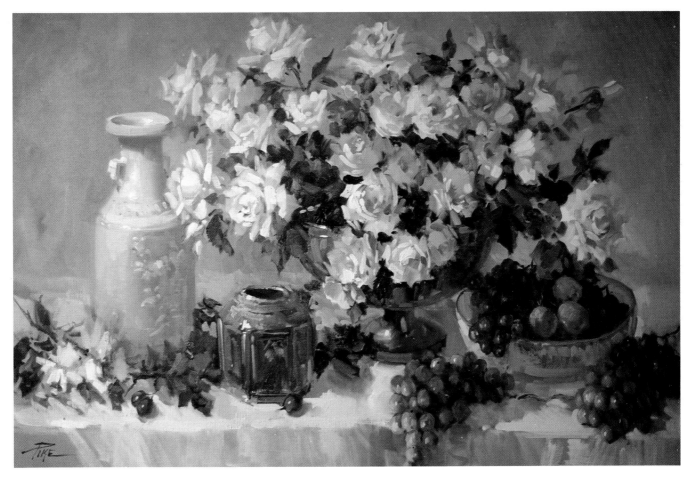

▲ *Blue Antique Ginger Jar and White Roses, 24 × 36*

The final step to relate area to area and object to object, making everything balance well. Losing and finding edges at this stage is a must. There are always elements that need to be quieted down and others to be brought up.

# Mixed Roses

◀ I have an antique ceramic washbasin with roses painted on it. I thought it would be fun to paint roses in a bowl with roses on it, with roses strewn on the table as well. The painting would be a little tighter than usual—just because I wanted it that way.

▶ I established my dominant hue (red and orange) and grays right from the beginning with an oil wash of every color I intended to use. No white was used at this time.

▲ *A Big Bowl of Roses, 24 × 30*

My intention was to paint each rose as a separate portrait, working tighter than usual. By using their colors in the background grays, I was able to use the many colored roses without disunity. I played down the pattern on the bowl.

### ▲ *Mixed Roses, 30 × 40*

Setting up a beautiful floral still life depends on moving things
around until everything balances and works. The drape I used for
this painting has beautiful blue tones over gold. I used the blue in
the background and the little blue vase to carry the complementary
blue tones around. The dominant hue is orange. The pinks and
yellows in the fruit and flowers combine to give a warm overall color.
The light on the table and background were also warm to balance
the blue hues.

# Roses with an Unusual Object

▲ This setup fell into place right from the beginning. Because I used several interesting objects in my setup, I needed fewer flowers. There is a lot going on in the foreground: orange peel, ribbons, cloth, fruit and cut fruit. All these beautiful colors are reflected onto the samovar. This is my favorite type of still-life painting, where so much is going on it takes a while to see everything. I think I enjoyed this because I had to be careful that the samovar, an unusual piece, did not take over the focus from the flowers.

◀ *Step One.* Orange is my dominant hue. The yellow and red are combined by the eye to make a warm overall orange glow. I first tone my canvas with the blue complement, with only a hint of yellow where I will place the flowers, fruit and hat. Because of the complexity of the setup, I take extra care with my drawing, working out all perspective carefully.

◀ *Step Two.* I go directly into finished color and grays, using white from the beginning. My idea was to use a direct approach, establishing grays so I could bring objects up to completion as soon as possible. When the setup is busy, it is easy to get carried away and overwork the painting, making things look too crowded. Placing all the final values and color from the beginning helps me know where it will be necessary to blend or lose edges.

◀ *Yellow Roses with Samovar, 24 × 36*

Carefully, I bring everything to completion, working all objects to the degree of finish I desire without taking away from the yellow roses, my focal point. I place a dark blue ginger jar against a black vase. Although the two blend, on closer examination you can see they are separate objects. Subtleties like this make for a good composition. Each foreground object is completed in detail, while objects in the background such as the hat are much softer with lost edges. Bringing your entire composition together means making everything work as a unit. Soft edges are often more important than crisp detail.

### ▲ *Soft Pink Roses and Antique Doll, 30 × 24*

This antique porcelain doll was given to me by one of my dearest friends and I am pleased to be the owner of such a treasure.

A figure like this would normally become the focal point in a still life. Yet I was able to include the doll and keep the flowers in center stage because of two factors. The first and most important is value: The whole doll, including the face, is painted in a medium value with no extreme contrasts. The second factor is color: The doll's colors pick up some of the colors of the roses. These two things keep the doll from attracting undue attention.

## SECTION FIVE

# *Painting Flowers Outdoors*

No painter should stay in the studio all the time. The clean, fresh air and the thrill of selecting things to paint in the great outdoors is a way for an artist to renew creativity. Drag a chair or table outside and make your setting look comfortable. Then select a spot where there are flowers, or place a few around like I have in *Setting in the Yard*. The matilija poppies in this setup were added; the shrubs were already there. Some of my selections for this section show the sky. Paint the sky or whatever you prefer—fences are great—but add something to show that you are outdoors. Outside, reflections are stronger and easier to see. Cast shadows are deeper and leave beautiful patterns where they fall. Strong lights on a sunny day are intense—almost blinding. There are many other qualities unique to outdoor painting that are too numerous to mention. So if things start getting a bit stale, if you feel a little tied up and want to do something different, do a setup outside. You will get plugged in all over again!

# Setting in the Yard

*"On a hot summer day use warm lights."*

I have a corner in my yard where many setups have been placed and models posed. Here there are some concrete steps, several rose bushes, and a retaining wall. All these elements make a cozy area where chairs, tables, or even a blanket can be placed on the ground and become ex-citing to paint. At a certain time of the year, I place large pots of petunias on the retaining wall. An orange tree grows in a large whiskey barrel with rusty bands and lots of character. I am describing all this to show you that you can do a lot to arrange things yourself. I also enjoy putting the lawn in some of my paintings. The grass makes it clear that I am painting outdoors.

▶ This is the corner of my yard where I set up a lot of my out-door paintings. There are many elements here to help me make interesting compositions.

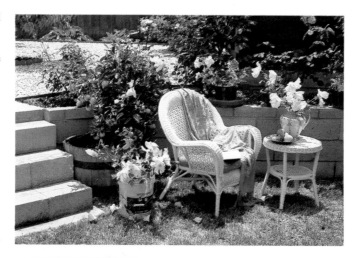

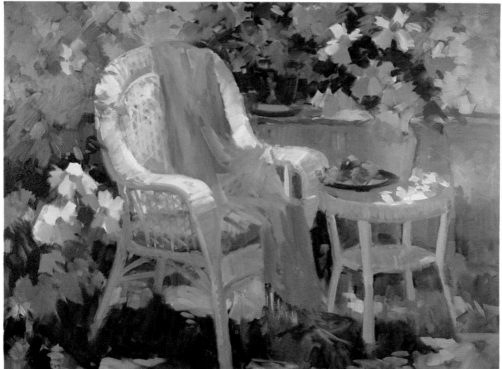

◀ The contrast is strong, and I want to show the strong bright lights hitting the white objects in front of the dark foliage. The strong cast shadow makes the composition complete. The blue shawl in the chair breaks up all the white. The entire paint-ing will be cool blue-green with beautiful warm lights hitting the whites. On a hot summer day, use warm lights. When there are clouds, or on an overcast day, your lights will be filtered mak-ing them cool.

### ▲ *Setting in the Yard, 30 × 40*

I bring in a few more poppies in the background and add detail to the ones in the pitcher on the wicker table. The embroidered flowers are added to the shawl. With a bit more refining, the wicker and fruit are brought to a finish. Once everything is complete, I add a few final touches of light on the chair, table and matilija poppies and also complete the yellow centers. When the viewer looks at a painting like this, they should want to be a part of it, to mentally feel comfortable sitting in the chair in the sunlight.

# Setting in the Apple Orchard

*"In an outdoor painting, cast shadows are one of the most important elements."*

It isn't always necessary to show sky or distance in the outdoor setup, but in this case I felt that the sky enhanced the outdoor feel. The dark fence behind the white wicker chair provides strong contrast, as does the black shawl. The umbrella has two purposes: to show transparency and to cast a shadow in an area where a dark was needed. I almost always add a dish of fruit to show life. I want the setup to look as though someone has just left the scene. The chair is actually on some rocks over which I laid a green blanket to make it look more like it was sitting on grass. I also made the fence much shorter than it actually was because I wanted to show the sky. Painting the apple trees was fun as a change of pace from flowers. There were a few morning glories in the back on the fence, but they barely show against the blue-violet background sky.

▲ Photograph of my setup.

▶ First, I scrub in the broad areas of value using loose, direct brushstrokes. I then draw the chair as accurately as possible. The umbrella is laid in with half-tones to vary the edge of the fence. Don't forget, it's much easier to add detail if all the parts are correct before detail is started. Notice how careful I am to secure the darks in my first lay-in, such as the cast shadows on the ground from the apple tree branch. I planned the ornate pattern of the chair right from the beginning, doing the shadows first, then the light. It is not difficult to paint wicker if you use at least three values and temperature changes. First I block in the structure, then add the frou-frou and the curlicues.

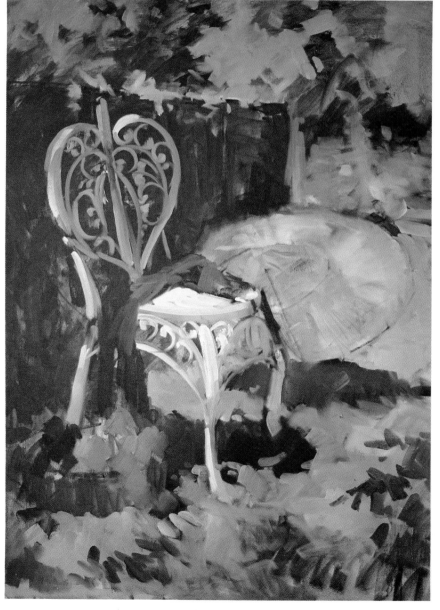

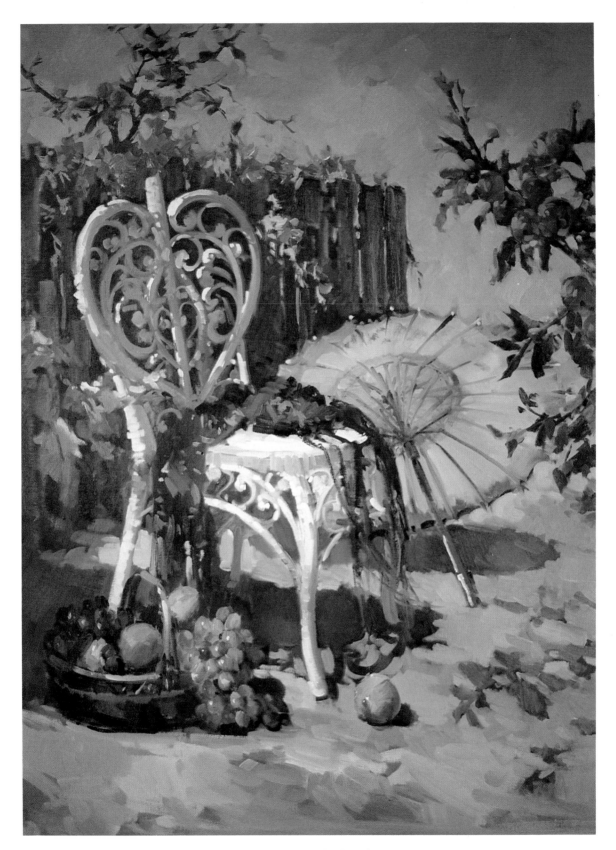

### ▲ *Setting in the Apple Orchard, 40 × 30*

I now work all around my canvas, completing areas to the degree of finish I want. Notice how dark my sky is. If I had gone too light in the sky, it would take away from the chair. The objects all fill the negative space well and, I hope, tell a story.

# First Roses of Spring

*"Bring some indoor objects outside for a fresh approach."*

In planning this painting, I wanted the bouquet of roses to be more important. The other elements would all have to be large to fill the canvas and show less of the background or surrounding area. I did include a cloudy sky behind the flowers to indicate that this painting was done outside. The hat was used on the lawn in the foreground, again to fill negative space. Garden and patio paintings are pleasing to view. Search for interesting objects to use outside and have fun painting them.

▲ *Step One.* After toning the canvas with a blue-green acrylic wash, I sketch in my objects to secure perspective. I quickly place in cast shadows, both their values and shapes, because they change so rapidly. I also start shaping the roses to suggest placement.

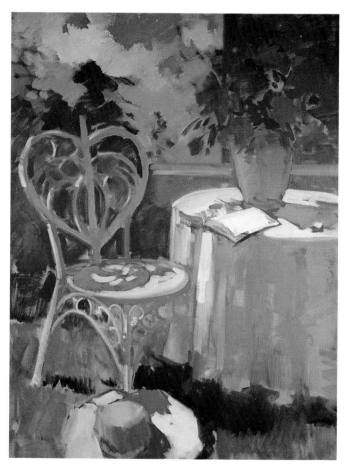

▲ *Step Two.* With broad, direct brushstrokes, I place in all of the values. Notice at this step that I had a dark corner of the building behind the flowers; I later changed my mind and repainted it as sky. The dark corner made the painting appear to be indoors looking through a window.

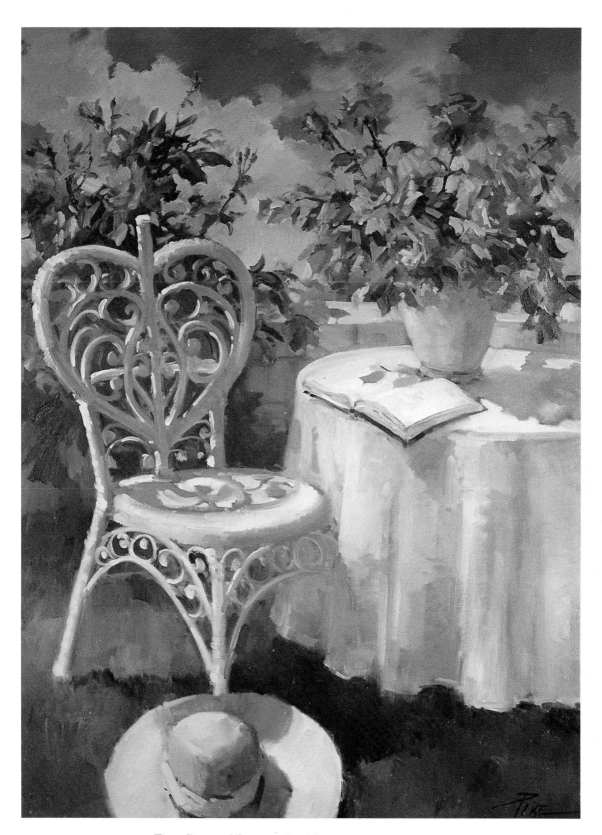

### ▲ *First Roses of Spring, 40 × 30*

All elements are now brought to a finish. Notice the cast shadows
have remained the same as when I started even though the light has
changed. It is always better to stay with the light direction of your
initial lay-in.

### ▲ *Called to the Phone, 40 × 30*

Again, I have used my backyard. The two levels make an interesting painting. For my setup, I stuck silk lilacs in the potted orange tree behind the chair. I also had some purple petunias potted in the wooden barrel. All the red-violet flowers worked as a complement to the yellow-green grass, trees and chair. When painting outdoors, you'll find that cast shadows often become some of the most important elements in your painting. I often do my setups around concrete structures such as these steps, which make beautiful blue-violet cast shadows.

### ▲ *Under the Peach Blossoms, 40 × 30*

I could have painted the beautiful apricot blossoms without the chair, and someday I plan to. But by now you know that I enjoy putting chairs in my outdoor setups as well as my indoor ones. The blossoms are pale pink, almost white, and I planned this beautiful tree as my background for the antique green chair. Dropping a few magazines around on the ground and on the chair also gave a human touch. A pot of pink geraniums was placed near the chair to emphasize the pink hue of the apricot blossoms and tie in with a soft pink scarf around the floppy hat. The painting has a blue-violet dominant hue, with warm grays used on the ground and around the painting to contrast with all the cool.

# Practice and Inspiration

Many people think of practice and inspiration as being unrelated. Practice is thought to be for beginners, and inspiration is something that concerns advanced painters. The truth is that an artist never advances to the point where he or she no longer needs to practice and that even beginners can be excited and inspired in creating even the simplest studies. It is also true that being constantly inspired is something else that takes practice. On the following pages I make suggestions for some good practice studies to do, as well as showing you some ways I get "re-inspired" for my work.

# Practice Makes Perfect

*"Do practice subjects to develop advanced painting skills."*

Enough can never be said for practice. Without it, your goals will never be accomplished; you will lack the tools to flesh out your inspiration. Practice need not be boring, but it must be repetitious. Do some practice subjects that make you solve specific problems. It is necessary to work hard, plan well, and stick with it until your goal is met. On the following pages are several paintings that were done as practice demonstrations. Each focuses on one particular problem in still-life painting. All were done in less than one hour, although time is not important. When painting practice subjects, use the following three steps: 1) Arrange the setup as perfectly as possible according to the color scheme and compositional balance. 2) Lay in the objects with little or no detail, using proper color and values. 3) Bring everything to completion using a minimum of brushstrokes — don't overwork.

► *Study in Yellow, 20 × 16*

In this study I wanted to demonstrate how to go dark with a yellow dominance. I mixed a dark that would approximate raw umber for areas such as the vase and figurine. If you look closely you can see some areas where I let some of the violet complement come through.

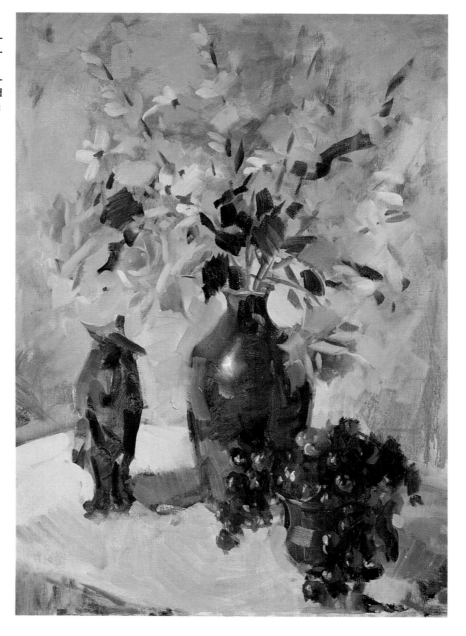

## MAKING DARKS WITH A YELLOW DOMINANCE

Yellow is always thought of as being light and airy. When you have chosen to use a yellow dominance, and a dark value is necessary, what do you do? To stay yellow but also go dark, I first consider the temperature of the dominant color. Yellow is warm, sitting between orange and green on the color wheel. A dark that would be in approximately this position on the color wheel is raw umber. Because I don't like to use earth colors, I make my own raw umber hue using sap green, which is a grayed yellow-green, with a small amount of alizarin crimson. The two make a beautiful, adjustable dark that can lean either toward yellow-green or red-violet.

## COMPLEMENTARY COLORS IN THE SUBJECT

In *Red and Green Study*, my background and tablecloth were grayed greens. I chose the red dahlias to incorporate my complementary color. The red rose pattern on the vase in the foreground tied together with the color of the flowers. The grapes in the candy dish and on the

▶ *Red and Green Study,*
*24 × 18*

The most important thing to remember when painting a subject having about equal amounts of complementary colors is to intermingle the colors all over the canvas. This will bring it all together.

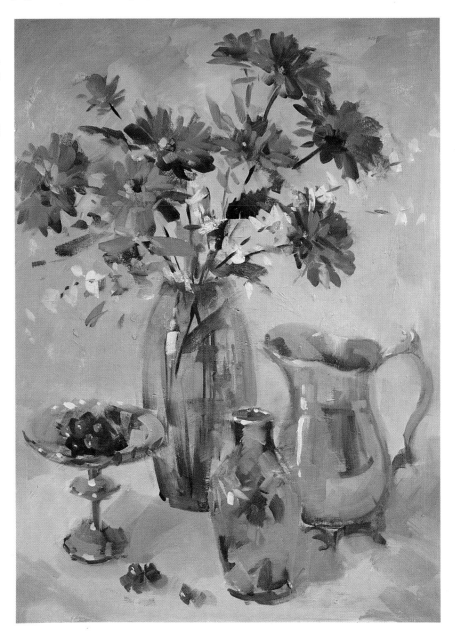

table also tied the red tones together. The strongest and brightest green was put in the large vase with the flowers. The dahlias were slightly grayed with green and the background slightly grayed with red. When painting a subject that includes complementary colors, it is important to intermingle the colors all over the canvas to create a sense of unity. Both silver objects were painted using reds and greens. Silver will take on whatever color is nearby, so it acts as an effective unifier. After everything was carefully laid in, I brought only a few critical areas into sharper focus. I refined a few dahlias and grapes and added a little detail to the small vase in the foreground. Even practice subjects can be finished.

## PAINTING WARM GRAYS

Mixing grays in the temperatures you want is an important skill to develop. Because most grays are made by mixing a cool color with a warm color, the temperature of your gray will be determined by the proportion of warm to cool. Each color has a different mixing strength,

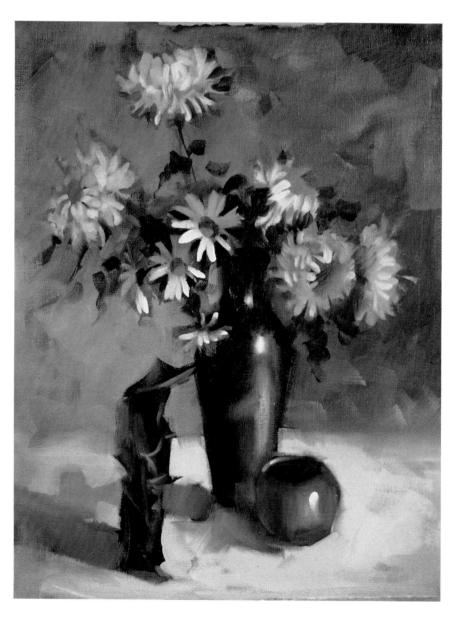

▲ *Painting Warm Grays, 20 × 16*

I wanted to do a very warm painting and adjusted my grays accordingly. I used chrysanthemums and daisies as my flowers because I needed something light against the rust background. The overall temperature of the painting is warm (red-orange), yet all the colors are grayed.

so experiment with each color on your palette to see how it affects the other colors. In my study, I chose a red-orange color dominance with a blue complement to gray. You can see the blue in the small bowl.

## COLORFUL SUBJECT ON A LONG CANVAS

My study was done on a long, narrow canvas. The problem was to paint objects such as the onions and make them very colorful and also to work in this unusual format. The dominant hue of the painting is yellow-green.

I used the complement red-violet in pure form and made it work. The red-violet complement was also used to gray the background at the top of the canvas to help tie some of the other violets together. Everything was painted with bold brushstrokes. Very little blending was necessary. I have included some closeups of the flowers and onions so you can take a good look at the brushwork. As I said in the beginning, practice need not be boring.

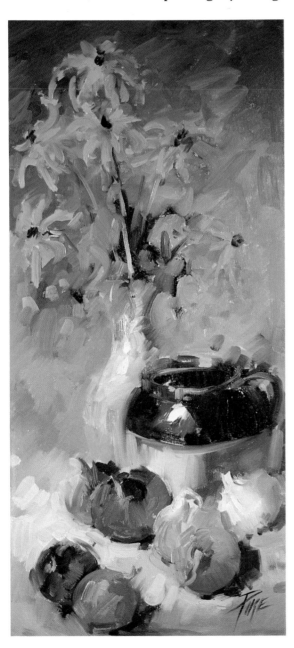

▲ *Colorful Study on Long Canvas, 24 × 12*

Working on a long narrow canvas stretches your artistic muscles. Here I decided to use very bright colors to see if I could make them work in this format.

▲ *Details.* The flower is a gloriosa daisy. Their natural color is very bright yellow-orange. You can see how the color of the petals almost melts into the color of the background in certain places. I used very little gray to paint the white, red, and brown onions. It was exciting to paint their jewel-like colors directly.

# *Finding Inspiration*

*"Don't sit around waiting for inspiration. Go out and find it!"*

Excitement about your work isn't something that just happens or doesn't. You need to purposefully seek out subjects or ideas that inspire you, usually simple things that make you really eager to get into your studio and paint. Each flower is unique unto itself. Likewise each painting should be unique. Every still-life setup should

be a little world of its own, the flowers and objects all relating in a special way. On the following pages, I show you some techniques that have helped me get inspired about my setups and to say something a little different in each painting.

## BUILD YOUR STILL LIFE PIECE BY PIECE

When doing a floral or still-life painting, one of the hardest things is to keep coming up with new ideas. Some-

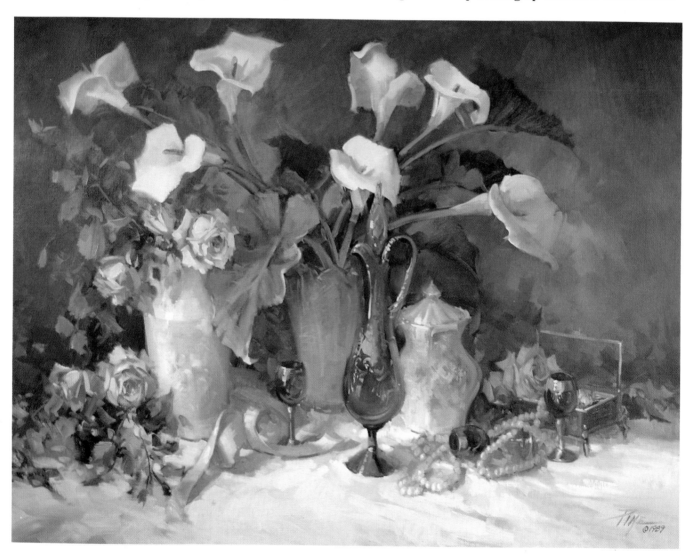

▲ *Calla Lilies and Pink Roses, 30 × 40*

times my interest in a still-life arrangement grows as I build the setup piece by piece. In the painting *Calla Lilies and Pink Roses* (below left), I wanted the stately calla lilies to dominate, but I also wanted to keep an overall softness to the painting. The pink roses were added for this reason. The small cracker jar decorated with pink roses tied in with the pink roses. The red decanter was added to break up all the white. I made a dark background to accentuate the lilies but not so strong as to take away the delicate look. I often use things like ribbons, jewelry, or flowers on the table to break up negative space. Don't be afraid to try new things. Each day should be a learning experience, no matter what your stage of development.

## BREAK A RULE

I had fun with the setup for *Lilacs and Calla Lilies*, below. I thought it would be interesting to arrange an equal

► *Lilacs and Calla Lilies,*
*36 × 24*

number of lilies in the vase and on the table, then split the composition, much like a mirror image—and make it work. The challenge was to make both sets of lilies interesting without having them fight for attention. As you can see, I selected the ones in the vase for my focal point. The white tablecloth reduced the contrast between the table and the lower lilies, allowing them to recede a little. The lilacs were used to show a dominant color and for visual pacing. Don't be afraid to break a rule. This painting is a good example.

## SET A MOOD WITH LACY TEXTURE

In *Lots of Lace* the mood is set. The painting is full of violet-grays with lace all over the place. The flower was chosen to fit in with the lacy look. I often use the large silver coffeepot when I want a delicate look; silver takes

▲ *Lots of Lace, 40 × 30*

around it, making it very soft. The cast shadows are part of the composition. I did not want strong contrast, so I adjusted my light source to cast softer shadows for the delicate look. I used no strong contrast in the entire painting. Color and value were worked out in my setup, making it easy for me to just paint what I saw. When I paint, I never think about detail. A few well-directed brushstrokes can give the appearance of a detailed piece of lace.

## FILL EVERY CORNER WITH FLOWERS

I had a large armload of real lilacs, gorgeous to look at and smelling as great as they looked, that I arranged in an antique pitcher. I decided to do *Lilacs and Daisies* on a square canvas and to fill the canvas with flowers. This released me from the usual flower-object arrangement. Almost every corner is filled. Very little negative space is seen. The daisies were placed in the painting to add contrast.

◄ *Detail.* This detail allows you to see two things. First, you can see my loose brushstrokes on the lacy hat. These direct strokes keep the painting fresh but give a very finished appearance from the usual viewing distance. Second, you can see how the silver coffeepot collects the colors around it, making it so soft it almost blends into its surroundings.

▲ *Lilacs and Daisies,*
*24 × 24*

## A DRAMATIC TABLE COVERING CAN GIVE YOUR PAINTING A THEME

My black Spanish shawl is used in a number of my paintings. The fringe is interesting as it drapes over a table edge or falls in an irregular pattern on the table. The embroidered roses on the shawl are bright red and yellow, almost screaming out their presence. By using red roses, I softened the intensity of the bright flowers on the shawl. The bowl of fruit also helped with the same problem. The eye still goes to the shawl first, but the supporting objects, also brilliant, attract the eye. Don't be afraid of color. Learn to work with it.

## PAINT IN AN INTERESTING, NEW LOCATION

Our local antique shop is filled with wonderful things from bygone days. The proprietor of this shop is a friend who graciously allowed me to set up in his store and paint. Don't be afraid to ask. All they can say is "no." This seventeenth-century mirror is a thing of beauty. The bronze statue is of equal interest. I used the bouquet of flowers to visually support the mirror and statue, placing my focal point where the statue is reflected in the mirror.

▲ *The Black Shawl, 30×24*

▲ *The Antique Shop, 40×30*

## GIVE YOUR PAINTING A REGIONAL FLAVOR

I had recently purchased some beautiful silk dogwood, as they don't grow on the central coast of California. While looking around my studio, I selected white blossoms to go with the dogwood. They looked great together. The dogwoods were Southern, and the blossoms looked Far Eastern, so I decided to select supporting objects with a regional flavor. The vase, fan and fruit bowl are all Eastern in origin. The porcelain pitcher added the Southern touch. The red in the fan added the touch of red needed to draw the eye from the vase.

## A PROP CAN MAKE A STATEMENT

One of my rose bushes produces a beautiful peach-colored rose. Not only is it colorful, but it is also prolific. For *Peach Roses*, I used typical still-life objects, only I added a magazine and scattered a few rose petals around on the table and on the open book. Fruit is also great

▲ *When South Meets East, 30 × 24*

for filling space and adding color. I try to find something in every painting to make a statement. The statement in this painting is in the open book. It says that people are near, and it also adds necessary contrast.

## CONCLUSION

Good luck. I hope you feel you have found a new friend or renewed your acquaintance with an old one. I truly want you to learn all I have to teach. If you will apply all of the suggestions I have made here, you can reach your goal; but not without hard work, perseverance, and a lot of practice. The journey is a long one. Don't give up—the reward is worth the effort. To the many students I have had the privilege of teaching in my workshops and to the many I hope to reach someday in the same way I would say, you are my jewels, and I truly enjoy every one of you. God bless you all.

▲ *Peach Roses, 24 × 30*

# Index